Hand Lettering
step · by · step

There are only four questions of value in life—what is sacred? of what is the spirit made? of what is worth living for, what is worth dying for. The answer to each is the same: only love.

Hand Lettering

step • by • step

techniques & projects to express yourself

creatively

kathy glynn

Get Creative 6

Get Creative 6
An imprint of Mixed Media Resources
104 West 27th Street
New York, NY 10001

Editorial Director
JOAN KRELLENSTEIN

Senior Editor
MICHELLE BREDESON

Managing Editor
LAURA COOKE

Art Director
IRENE LEDWITH

Book Design
ALISON WILKES

Associate Editor
JACOB SEIFERT

Still-Life Photography
ANTONIS ACHILLEOS

Step Photography
KATHY GLYNN

Production
J. ARTHUR MEDIA

———————————————

Vice President
TRISHA MALCOLM

Publisher
CAROLINE KILMER

Creative Director
DIANE LAMPHRON

Production Manager
DAVID JOINNIDES

President
ART JOINNIDES

Chairman
JAY STEIN

Library of Congress Cataloging-in-Publication Data
Names: Glynn, Kathy.
Title: Hand lettering step by step : techniques and projects to express yourself creatively / by Kathy Glynn.
Description: First Edition: New York : Get Creative 6, 2018. | Includes index.
Identifiers: LCCN 2017028519 | ISBN 9781942021858 (pbk.)
Subjects: LCSH: Lettering--Technique. | Handicraft.
Classification: LCC NK3600 .G59 2018 | DDC 745.6/1--dc23
LC record available at https://lccn.loc.gov/2017028519

Manufactured in China

1 3 5 7 9 10 8 6 4 2

First Edition

ACKNOWLEDGMENTS

Thank YOU! Thank you for taking a peek at this book and for your willingness to open yourself up to your creative possibilities. I hope this book inspires you to create!

I thank God for the gifts he has blessed me with. To my children, Alexandria and Robbie: Thank you so much for all your love and support, for always believing in me, and for dealing with all that comes with having a mom who is an artist. I love you more than words can say. To my darling Casper: I hope I make you proud! To my sweet sister, Tammy: Thank you for always being there. To Aarika and Jakob: Thank you for being so sweet and loving. I love you all. To my gorgeous Ronnie P.: Without you, this book would not have come to fruition. Thank you for all your love and support, for cheering me on, and for providing me great wisdom whenever I was in doubt. You have loved me like no other. You bring me great joy, pleasure, and deep belly laughs! I love you so much!

To Carrie Kilmer: Thank you for believing in me and for bringing me into the fold of West Broadway and the world of publishing. It has been a great adventure working with you these last six years. You are a great mentor, role model, and dear friend.

To Michelle Bredeson: Thank you for all of your patience, for helping me through the shadows of being an artist, and for working diligently to create a beautiful and informative book.

To Irene Ledwith: Thank you for all your patience and hard work in creating a truly beautiful book.

To Jay Stein and Art Joinnides: I thank you for this opportunity.

CONTENTS

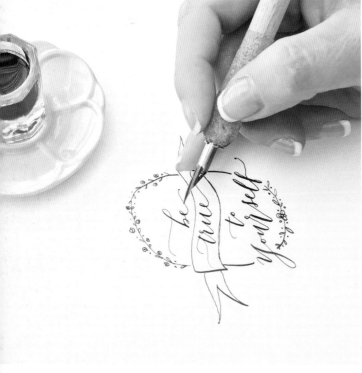

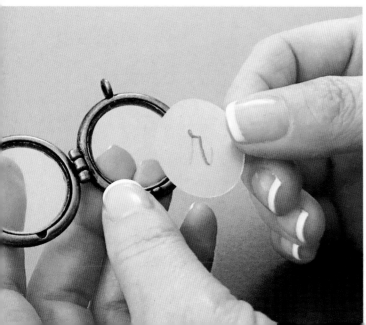

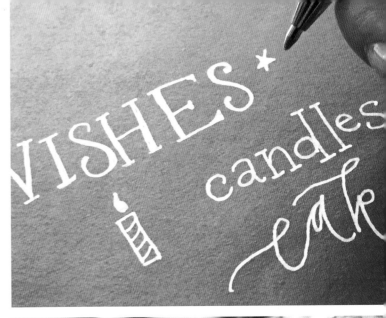

CHAPTER 3
DRAWING LETTERS

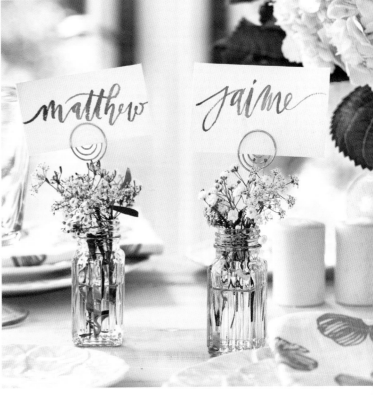

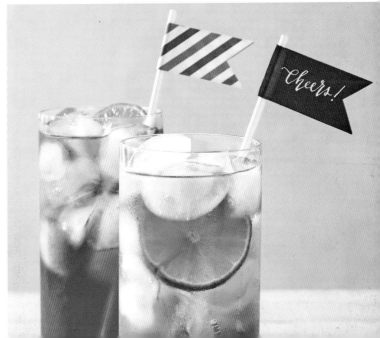

Lizbeth Ann Keller
6•26•87

James Michael Keller
12•15•85

4•10•59

6•15•62

Michael Jack Keller

Lisa Ann Adams

11•9•55

12•19•63

Andrew Thomas Adams

Emily Valerie Newton

5•24•65

John James Adams

Laura Michelle Perkins

2•29•67

Robert Andrew Adams

10•24•92

1989

1982

1992

3•12•39

9•12•32

Elizabeth Ann Kennedy

James Andrew Adams

1958

The Adams Family

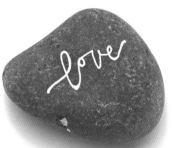

INTRODUCTION:
FOR THE LOVE OF LETTERING

IN TODAY'S DIGITAL AGE, people crave the touch of the handmade. Lettering is a timeless art form that is experiencing a renaissance of popularity.

I have loved art and letters my whole life. I giggle today imagining what my fifth-grade teacher must have thought when I did all my homework assignments in bubble lettering! I began my journey in calligraphy as a therapeutic ritual after a difficult time in my life. It helped me to slow down, be still, and journal my thoughts and feelings in a special way. My ritual consisted of pulling out my supplies, lighting a candle, putting on my favorite music, and sipping a little wine or champagne. I still delight in this ritual, although some days I opt for my favorite coffee, tea, or sparkling water. Calligraphy wasn't the first type of lettering I learned. I actually began brush lettering before I attempted to do pointed-pen calligraphy, but it wasn't until I learned calligraphy that I began doing lettering professionally. I couldn't believe I could get paid for writing letters!

As a self-taught lettering enthusiast, learning calligraphy and lettering has been a meditative experience that celebrates the beauty in imperfection. Although I admire the accuracy, perfection, and beauty of classic calligraphy, this book is not about learning the technical skills of a master calligrapher. I will introduce you to the basics of creating letterforms using modern calligraphy, brush lettering, and other hand-lettering techniques. You'll discover the anatomy of the letter, the basic strokes and techniques to create letterforms, and the supplies you need to get started. Each section contains fun projects to incorporate what you have learned and to spark your own ideas. I encourage you to use this book as a starting point in developing your own style of lettering—lettering that feels natural, expressive, and authentic to you.

Most of all, I hope that you will take the time to slow down, take up your pen or brush, and allow yourself the opportunity to express your creative spirit. Let's get started.

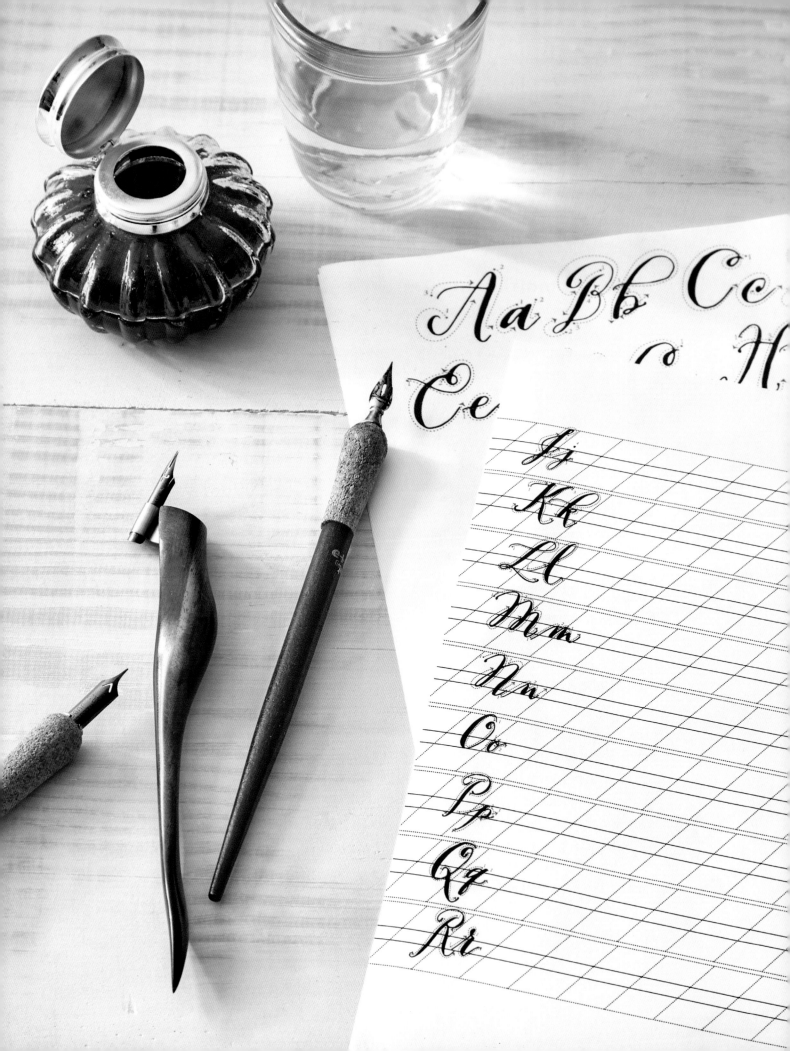

Modern Calligraphy

"MODERN" CALLIGRAPHY loosens up the formal style of traditional calligraphy and allows for more creative freedom. As in traditional calligraphy, the letters of modern calligraphy are formed with a pointed-nib dip pen. It's my favorite way to create letterforms. I love the sound of the metal nib softly scraping across smooth paper and the beautiful letterforms and embellishments that can be created with this tool. In this chapter, I will introduce you to the supplies you will need to get started, ideas for developing different styles, and craft projects that let you exercise your newfound skills!

THE CALLIGRAPHY STUDIO

Calligraphy supplies are relatively simple and inexpensive. When I first began calligraphy, it was much harder to find these supplies, but as the interest in this old art form has increased, the availability of supplies has improved considerably.

THE NIB

In this chapter, we'll be focusing on calligraphy using a dip pen with a pointed nib. Dip pens are filled by dipping the nib directly into the ink, unlike fountain pens, which have an ink reservoir within the body. Dip-pen nibs come in two varieties: broad edge and pointed. The pointed nib creates letters by using various strokes and different amounts of pressure. (The broad-edge nib creates a different style of calligraphy, which we will not cover in this book.)

The more flexible the nib, the thicker the lines it produces. The firmer the nib, the thinner the lines. The size of the point contributes to the quality of hairlines (very thin lines). I encourage you to try a variety of nibs to see what you like best.

The Anatomy of the Nib

To help you understand how a nib works, let's look at its construction.

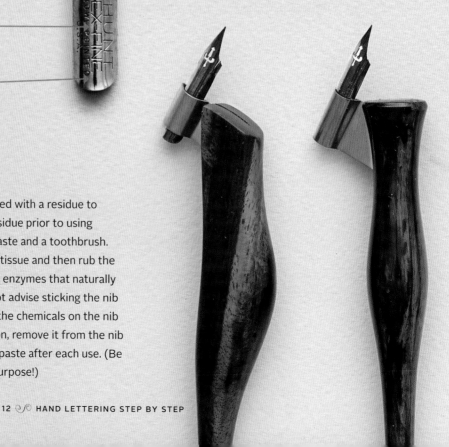

RESERVOIR: The open oval shape within the nib where the ink sits. As the tines separate, the ink flows from this reservoir. When the reservoir is depleted, it's time to dip the nib in ink.

BODY: The section of the nib between the reservoir and the base of the nib.

BASE: The bottom portion of the nib that is inserted into the nib holder.

TIP: All pointed nibs have a pointed tip made of two tapered tines. The shape and size of the point will dictate the quality of the hairlines produced by the nib. Letters are created by moving the point of the nib on paper.

TINES: The two tapered tines give the nib flexibility. When pressure is placed on the nib, the tines separate, allowing the ink to flow. The harder the pressure, the thicker the line.

Caring for Your Nib

When you first purchase your nib, it will be coated with a residue to prevent the metal from rusting. Remove this residue prior to using the nib by scrubbing the nib with a little toothpaste and a toothbrush. Alternatively, you can spit into a paper towel or tissue and then rub the nib onto the towel or tissue. Our saliva contains enzymes that naturally break down the chemical on the nib. (I would not advise sticking the nib in your mouth, because I am not sure how safe the chemicals on the nib are to ingest.) To keep your nib in good condition, remove it from the nib holder and clean it with a toothbrush and toothpaste after each use. (Be sure to keep a designated toothbrush for this purpose!)

PEN HOLDER

Pen, or nib, holders come in two types: straight and oblique. Choosing the right holder for you is a matter of personal preference. A straight holder looks very much like a pen. An oblique holder features a protruding flange that places the nib at an angle. The oblique holder was created to make it easier to write at an angle. There are advantages to using an oblique holder, but for beginners, I find straight holders are less intimidating because they are more reasonably priced and feel closer to a pen or pencil. Holders also come in different weights and sizes. Try different holders until you find one you like.

Inserting the Nib

How you place your nib into the holder depends upon the holder itself. If the pen insert of the holder is round with a ring of circles, insert the nib into the space between the two circles. Push it into the holder until the nib stops and feels securely in place. If the pen insert of the nib holder has a rim and four prongs, place the nib between the rim and the prongs. Push the nib into the holder until it stops and feels securely in place. Do not place the nib within the center of the prongs.

BEGINNER'S TOOLBOX

The list of supplies I recommend specifically for beginners includes:

Nikko G pointed nib: A hand-cut, chrome-plated nib with a medium amount of flex.

General's cork-tipped pen holder: This type of holder provides cushion for the fingers.

Winsor & Newton Calligraphy Ink in black: A pigmented, lightfast, nonwaterproof, smooth black ink that dries matte.

Canson Pro Layout Marker paper: A semi-transparent, acid-free, non-bleedable white paper.

Dappen dish or other small container to hold ink.

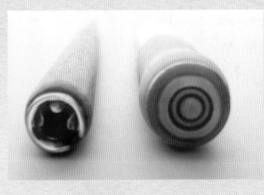

Pen holders have either four prongs for inserting the nib (left) or two circular openings (right).

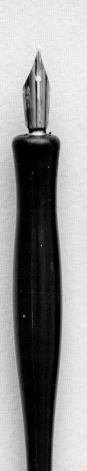

An oblique pen holder places the nib at an angle.

INKS

There is a wide range of inks with a huge variety of colors you can use for calligraphy. Amazing as it may seem, there are even many colors of black inks. Some dry matte, others dry shiny. Below is a simple breakdown of inks and my preference for each type. Even within these categories, you will find variations. My best advice is to explore and experiment with several inks to find which ones work best for you.

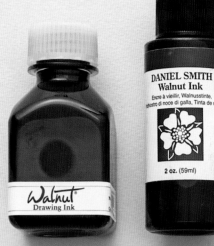

Sumi Ink

Sumi ink is typically made from carbon soot or vegetable soot. Some sumi inks are waterproof. Popular waterproof sumi inks include Moon Palace, Yasutomo Sumi, and Kuretake Sumi. The popular brand Best Bottle Sumi is not waterproof. Most sumi inks are black, but you can also find sumi ink in vermillion (a bright orange) and a chalky white. Mixing the bright orange with black creates a nice sepia ink.

Walnut Ink

This is a richly colored transparent brown ink made from the husks of walnuts. It can also be used as a wash similar to watercolor. Purchase it in liquid or crystal form. Simply add water to the crystal form until it creates the consistency you prefer. Popular brands include Daniel Smith Walnut Ink (liquid form) and Walnut Ink Crystals from Paper & Ink Arts.

Iron Gall Ink

Iron gall is a purple- or brown-black ink made from iron salts and tannic acids. It's known for creating beautiful hairlines. The two most popular iron gall inks are McCaffery's Ink and Old World Ink. If the calligraphy piece you're creating is for historical documentation, I do not recommend this ink because it is corrosive and will damage the paper over time.

Dye Inks

Dye inks get their color from chemicals. The colors can be very brilliant but they are not lightfast, so I don't recommend them for lettering you want to last. Popular brands include Dr. Ph. Martin's Radiant Watercolors and Econoline Watercolors. Inks made for fountain pens are dye inks.

Pigment Inks

Pigment inks are made from pigments combined with a binder. They may need to be thinned with water if the ink does not flow easily. Their colors are slightly less intense than dye inks, but they are more lightfast. Winsor & Newton Calligraphy Ink is my go-to ink for most calligraphy inks. Daler-Rowney FW Acrylic Artists Ink is acrylic based. Both come in a variety of colors.

INKWELL

You could dip your nib directly into a bottle of ink, but it can be very messy if you get ink on the grip of the pen holder. Also, leaving the cap open on the ink bottle for an extended period of time can change the consistency of the ink. I recommend using an inkwell. Traditional inkwells are not commonly found, and antique inkwells can also be pricey and in poor condition. I recommend using a dappen dish (also called a dappen glass).

Dappen Dish

A dappen dish makes it easy to see the nib when you dip it in the ink and to ensure that the reservoir has been fully loaded.

JAR OF WATER

After 5 to 10 minutes of redipping the nib into the ink it will begin to dry and gunk up. Dip your pen in a jar of water when the ink gets gunky, then clean it off with a paper towel.

PALETTE

To mix watercolors, you'll need to use a palette. Palettes come in a lot of different shapes and sizes. A palette with depressions in them to hold the paint will keep the paints from running together. I use the middle section to mix colors.

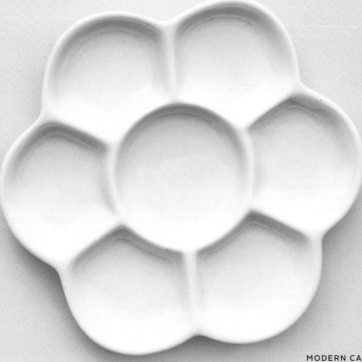

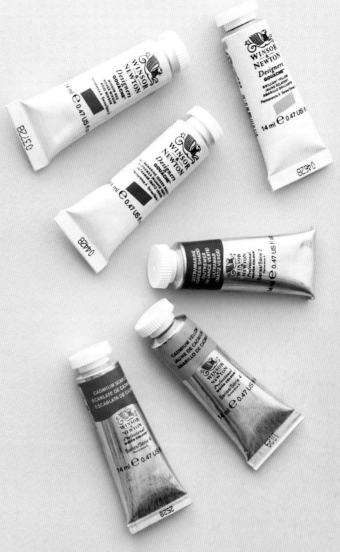

WATERCOLOR AND GOUACHE

Another option, especially if you're looking for a specific color, is to use watercolor or gouache. Watercolor paint is transparent, while gouache is opaque. You can mix the paint with water to lighten the color. You can also combine various colors to create a specific color. If the paint becomes too thin, add a small amount of gum arabic to thicken it.

Watercolors and gouache come in two forms: tubes and pans. The benefit of using paints in tubes is that you can mix larger batches of color, which you can store in jars. If you use watercolors or gouache in pan form, mix the paints to the desired color, and then load the paint onto the nib with a paintbrush.

Paints also come in two grades: artist and student. The difference between artist- and student-grade paint is price and quality. Watercolors are made up of pigment and binder. The binder is what holds the pigment together and also allows it to adhere to the paper once it's been applied. Student-grade watercolors contain more binder and cheaper-quality pigments than artist-grade paint and, therefore, are less expensive. Higher-quality paints are more light resistant.

METALLIC PAINTS AND PIGMENTS

Metallic inks will give your lettering projects a rich look with a little sparkle. Finetec mica paints and Pearl Ex pigments are wonderful products to use to get a shiny, metallic effect.

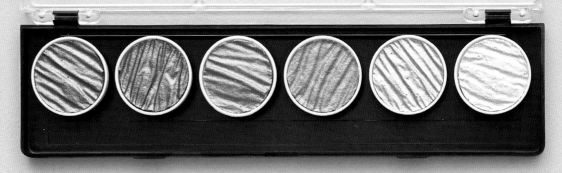

Finetec Mica Paints

Finetec mica paints come in a wide variety of gold, silver, pearl, and iridescent colors. These paints work like watercolors. Once you wet these paints with warm water, they become creamy, thick metallic paints that adhere nicely to the metal nib. Load the nib with a watercolor brush.

Pearl Ex Pigments

You can also mix up a calligraphy ink using Pearl Ex pigments. To create an ink mixture, mix four parts pigment to one part gum arabic (see below) with distilled water. The amount of water you use will determine the consistency of the ink. As a rule of thumb, use the same amount of water as pigment. For example, I mix 1 teaspoon of pigment with ¼ teaspoon of gum arabic and 1 teaspoon of water. Adjust the consistency of the ink by adding more or less water.

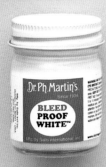

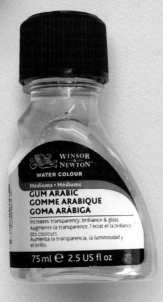

DR. PH. MARTIN'S BLEED PROOF WHITE

Dr. Ph. Martin's Bleed Proof White is an opaque white watercolor made for covering mistakes. Calligraphers have developed the use of it for lettering on dark papers for a striking effect. See page 42 for more on using this versatile product.

GUM ARABIC

Gum arabic is made from the sap of the acacia tree. It comes in a liquid or powdered form and has a number of uses, including helping to thicken inks and watercolors that are too thin and to give them a crisp edge.

PENCIL AND ERASER

A pencil is a must-have for sketching out lettering designs. I prefer a soft 2B lead, either traditional or mechanical. A kneaded eraser makes it easy to erase stray pencil marks.

PAPER

Papers used for calligraphy should be smooth or it will be difficult to control the nib. You will also need to test the paper to see whether the ink bleeds. Good-quality paper contains internal "sizing," which reduces the bleeding of the paper.

Practice Paper

HP Premium Choice laser paper (32 lb.) is a good economical paper for practice. Another option that is a little pricier is a semi-transparent paper called Canson Pro Layout Marker paper. This is a good paper to use to design images that will later be digitized or to practice new letterforms. Other brands make similar types of paper. Vellum paper is ultra smooth, but it may be on the pricey side for everyday practicing. I do not recommend this paper if you're going to scan and digitize your lettering, because it will look cloudy.

Stationery Paper

When it comes to purchasing papers for wedding invitations or social events, stationery paper can be hit or miss. Before investing in a large amount of envelopes or stationery paper, buy sample papers to test. If the ink tends to bleed on the paper, one trick of the trade is to sprinkle gum arabic (in powder form) onto stationery and envelopes to improve the paper sizing. Sprinkle the powder onto the paper and move it around until the area that you will be writing on is covered by the powder, then tap the paper, allowing the excess powder to fall onto another piece of paper to salvage and place back into the jar. The thin layer of powder will help absorb the excess ink.

Watercolor Paper

You can also use artist-grade watercolor paper for cards and invitations. I prefer 140-lb. hot-press watercolor paper because it has a smoother tooth. Cold-press paper is harder to work with because the rough surface makes it more difficult to control the nib, and paper fibers tend to get stuck between the tines.

Other Papers

Other options include smooth Bristol paper or card-stock paper. Bristol paper is a good choice to create framed quotes in ink and watercolor. For colored paper options, a 65-lb. card-stock paper works well. The sizing and weight of these papers vary by brand. It's best to buy small quantities and test the paper.

THE ANATOMY OF A LETTER

Let's take a look at the anatomy of a letter. In calligraphy, the letter is formed by making a series of strokes. You'll learn to make the basic strokes and start creating letters.

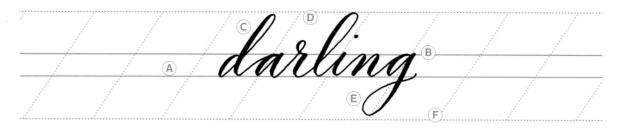

A **BASELINE:** The line on which the main body of the letter sits.

B **X-HEIGHT:** The distance between the baseline and the top of the main body of the letter without extensions (ascenders and descenders).

C **ASCENDER:** The part of the letter that extends above the x-height of the letter.

D **ASCENDER LINE:** The line designating where an ascender extends to.

E **DESCENDER:** The part of the letter that extends below the x-height of the letter.

F **DESCENDER LINE:** The line designating where a descender extends to.

You are capable of amazing things

CALLIGRAPHY BASICS

Now that you have some basic supplies to get started, it's time to put pen to paper. In this section, you'll learn the different strokes that create letterforms. Let's get started!

PREPARING TO WRITE

To begin, sit up straight in your chair with your shoulders back. It's important to maintain good posture and not slump over when making your strokes. Hold the nib holder similar to how you hold a pencil. Your fingers should be placed ⅛ to ¼ inch above the end of the holder. If you want your lettering to slant to the right, turn the paper counterclockwise; if you want it to slant left, turn the paper clockwise.

BASIC STROKES

Let's begin by getting comfortable holding the pen and making some marks. Dip your nib into the inkwell so that the reservoir of the nib is fully immersed in the ink. Slide the edge of the nib against the wall of the inkwell to remove the excess ink on the nib. Place a piece of translucent marker paper (such as Canson Pro Layout Marker) over the top of the Calligraphy Practice Strokes practice page (found at the back of the book). Practice making each stroke until it becomes natural. The key to writing with the dip pen is to take your time. Slowing down and observing how the nib works will help you gain control of your strokes.

NOTE ❯ **The slanted lines you find on practice sheets are meant to help keep the angle of your strokes consistent.**

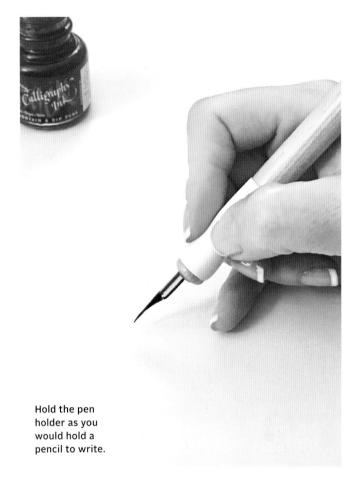

Hold the pen holder as you would hold a pencil to write.

First Stroke

Using your guidelines, begin making a stroke, moving the nib from the top of the guideline down to the baseline. The slant on the practice sheet will assist you with the slant of the strokes.

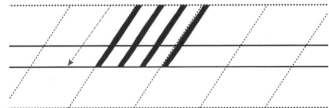

Downstroke

Once you've become comfortable making downward strokes, try applying pressure in your downstroke to create a thick line. You will see that the tines separate when pressure is applied and spring back together when pressure is released. If you allow the tines to work naturally, the top and bottom of each stroke will be squared off.

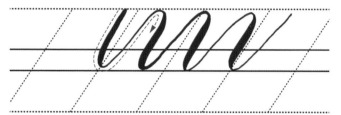

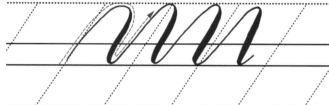

Down Up Stroke

Try creating a combination of a thick downstroke by applying pressure and then a thin stroke by releasing the pressure as you create your upstroke. See how the nib will work for you in creating thick and thin lines.

Up Down Stroke

Now try the opposite, starting with a light upstroke and heavy downstroke. Continue practicing these strokes to become comfortable creating thick and thin lines.

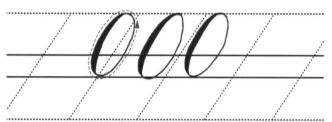

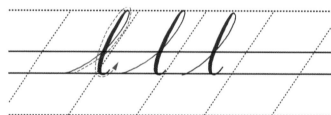

O Stroke

The O stroke is used to create capital and lowercase Os as well as letterforms that contain an O shape, such as a lowercase *a* or *d*. Start at the top of the guideline, a little to the right, with little or no pressure. As you curve and begin to move down, start applying pressure in the downstroke. Then lessen the pressure as you curve around and begin the upstroke. Curve the upstroke and meet the starting point of the letter.

Ascender Loop

Begin by moving the nib from the baseline to the ascender line in a light upstroke. Then as you begin to curve around, start applying pressure in the downstroke until you reach the baseline. Then curve around, releasing the pressure as you move into your upstroke.

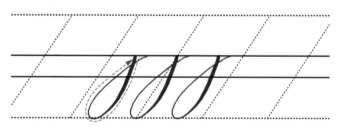

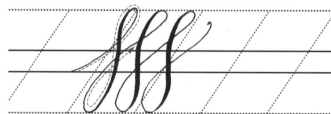

Descender Loop

Starting at the x-height, apply pressure as you move down toward the descender line. As you start to create the curve of the loop, begin releasing the pressure as you curve around and across the downstroke, ending at the x-height line.

Ascender Descender Combo

Follow the instructions for the ascender loop, then when you reach the baseline continue down to the descender line. Then follow the descender loop instructions until you reach the x-height line. Then continue back into an ascender loop.

WARMING-UP EXERCISES

Whenever I begin writing in calligraphy, I start with the basic strokes to warm up. Here are a couple more strokes I use as part of my warm-up drills. Mastering these strokes will ensure good control of the nib. They're similar to the O stroke.

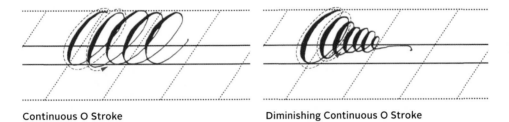

Continuous O Stroke Diminishing Continuous O Stroke

CONTINUOUS O STROKE

As in writing the letter *O*, start at the top of the guideline, a little to the right, with little or no pressure. As you curve and begin to move down, start applying pressure in the downstroke. Then lessen the pressure as you curve around and begin the upstroke. Instead of making a complete *O*, the focus of this exercise is to make loops with thick downstrokes and thin upstrokes at a quicker pace to exercise control.

DIMINISHING CONTINUOUS O STROKE

As with the continuous O stroke, the focus of this exercise is to write at a quicker pace to exercise control. Follow the same instructions as the continuous O stroke. Create loops with thick downstrokes and thin upstrokes. However, in this exercise, the loops should get smaller with each loop around. The focus of the exercise is to gain control and accuracy with your strokes.

These two exercises really help loosen me up in the same way an athlete stretches before a race.

TROUBLESHOOTING

Don't get too frustrated with the pen. It does take a little practice to learn to use it comfortably and fluidly. Here are some common problems beginning calligraphers run into and ways to avoid them.

PROBLEM: Scratchy Results

SOLUTION: The tines do all the work of creating thick and thin lines based on the amount of pressure applied. The harder you press, the more ink flows down through the two tines, because the tines are wider apart. The lighter you press, the less ink flows, as the tines are closer together. In order for this to work well, the tines need to be flat to the paper.

If the tip of the nib is not flat against the paper, the line will be thin and scratchy (left). Keeping the tines flat will ensure a smooth line (right).

PROBLEM: Ink Blobs

SOLUTION: Ink blobs occur when there is too much ink loaded into the nib. Be sure to remove excess ink by sliding the nib against the lip of the inkwell. I gently tap the nib on a piece of scrap paper prior to creating my first stroke. This gives me a sense of how the ink is flowing on the nib. If the nib is overloaded, I tap it against the inkwell again to get rid of the excess ink. I do this before almost every stroke I create.

TIP ❯ Using a higher-quality ink will help keep blobs from forming.

Too much ink causes blobs to occur (left). Removing excess ink creates a cleaner line (right).

PROBLEM: Ink Runs Out Mid-Stroke

SOLUTION: Over time you will get a sense of how long the ink will last. It varies based on the type of ink and nib you're using. It's best to re-dip your nib after a downstroke. This way, you can begin the upstroke from inside the downstroke and the stroke will look seamless. It's much harder to create a seamless connection when joining from a thin line (upstroke). Also, if the ink runs out during a downstroke, you can fill in the empty space of the stroke with the pointed tip of the nib.

Here the ink ran out mid-stroke.

Fill in the gap with the pointed tip of the nib.

THE LETTER EXEMPLAR

Now that you know the basic strokes to create letters, you can begin practicing actual letters. On the next page, I have provided a letter exemplar—a complete alphabet that shows a style. In this example of one of my personal styles, I show the sequence of strokes for each letter.

For example, to create the uppercase *A*, follow these steps:

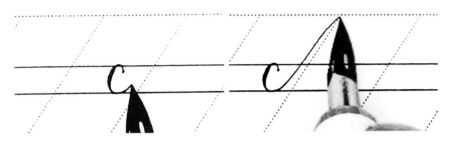

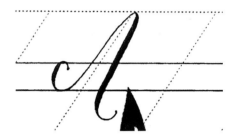

1 To create the opening loop, begin at the x-height and make a rounded downstroke to the baseline. Without lifting the pen, make an upstroke that reaches the ascender line. I've broken this step into two photos to show more detail, but it is really a single stroke.

2 Change direction and make a downstroke that reaches slightly below the baseline and ends with a slight upstroke.

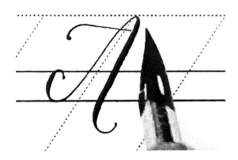

TIP ❯ **To form a "dot" at the beginning of a stroke, pause briefly to let the ink pool slightly.**

3 Make a cross bar that begins with a curved stroke and crosses the *A*.

To create the lowercase *a*, follow these steps:

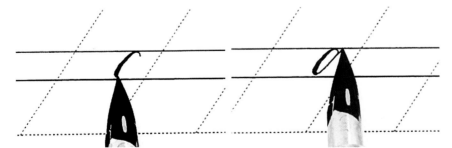

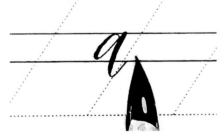

1 Beginning at the x-height, make a rounded downstroke. At the baseline, continue into an upstroke that almost reaches the x-height. This should be done as a single stroke.

2 Make a downstroke from the x-height to slightly below the baseline, ending with a tail.

Begin practicing each of the letters. You can lay translucent marker paper over the page and trace to get started. Once you have a little practice, I encourage you to begin creating letters without tracing. Perfecting each letter is not the objective. Instead, use these examples to get comfortable using the pen so you can start creating your own style.

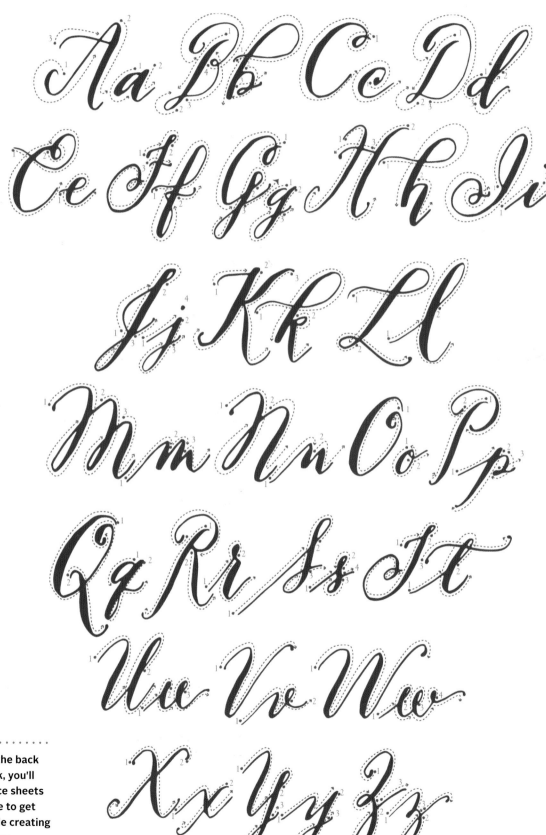

TIP ❯ At the back of the book, you'll find practice sheets you can use to get comfortable creating these letters.

CONNECTING LETTERS

Now that you have some practice creating individual letters, you're ready to move on to words!

Most letters end in a downstroke with a slight upstroke at the end of the letter. Continue the ending upstroke into the next letter.

For pleasing word and sentence flow, strive to make each letter slant at the same angle. The slant on the practice sheets is to assist with the slant of the letters. You do not have to slant the letters at a specific angle. Many styles of modern calligraphy are written without an angle. The key is to form each letter at the *same* angle.

The spacing between the letters will create the visual rhythm of your calligraphy. Generally speaking, the spacing between the letters should be even.

darling

RIGHT: Here, the slant and the spacing are equal, giving the lettering a pleasing look.

darling

WRONG: When the slant varies within the word, it looks messy.

darling

WRONG: Unequal apacing also gives the lettering a sloppy look.

CREATING YOUR OWN STYLE

It took me many years of practice to perfect my signature style. Have patience: The more lettering you do, the more naturally your style will emerge. Here are a few ways to vary the basic lettering to consciously change the style.

VARIATIONS IN BASELINE AND X-HEIGHT

Once you become comfortable with the basic letterforms, you can be more expressive with words by varying the baseline and x-height of the word. Varying a few select letters from the baseline while maintaining the remaining letters on the baseline will keep the word grounded.

In this example, the letters *r* and *l* are slightly below the baseline, while the *n* and *g* are slightly above.

Here, not all the letters are sitting evenly on the baseline and the letters *r* and *n* extend beyond the standard x-height.

ENTER AND EXIT LINES

Extending the stroke leading into the first letter of a word or the final stroke of the last letter is an easy way to add some further interest to your lettering.

VARIATIONS IN SPACING

Another stylized effect can be made by changing the spacing between letters. This will change the rhythm of the style.

Although the letters are spaced farther apart, the spacing is even, which creates a nice rhythm.

Here the letters are spaced apart and the baseline varies. The *l* is slightly below the baseline, while the *g* is slightly above.

Another example of spacing and baseline variation. The letters *r* and *l* are below and *g* is slightly above.

NUMBERS AND PUNCTUATION

To create numbers and punctuation marks, use the same method as in creating letters—thick downstrokes, thin upstrokes, and transitional curves. Punctuation marks can be a fun and creative element in your designs.

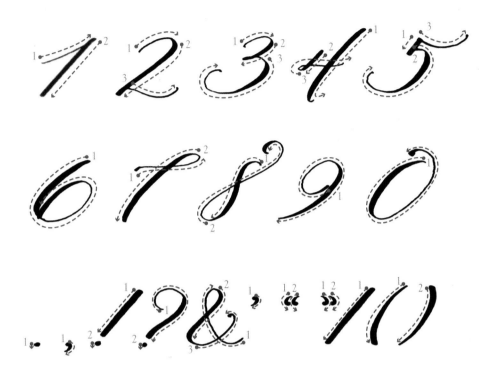

THE PROJECTS

Now that you have spent some time practicing strokes, letters, and words, you're ready to really have some fun! In the pages that follow, I share detailed, step-by-step instructions for a variety of projects that incorporate calligraphy. All are created by hand; in some projects, the lettering is digitized.

While these projects all showcase modern calligraphy, many of them can be adapted to incorporate brush lettering, which is covered in the next chapter, or drawing letters (see page 92). Every project includes a Variations sidebar with suggestions for other ways to create the projects, use the featured techniques, or both.

At the beginning of each project, I list the exact materials I used so that you can recreate it if you wish. However, feel free to try out the materials you have or other supplies. You may not get the same results, but you could come up with a unique design!

"Finding someone you love and who loves you back is a
wonderful, wonderful feeling. But finding a true soul mate
is an even better feeling. A soul mate is someone who
understands you like no other, loves you like no other, will be
there for you forever, no matter what. They say that nothing
lasts forever, but I am a firm believer in the fact that for
some, love lives on even after we're gone."

Cecelia Ahern, *P.S. I Love You*

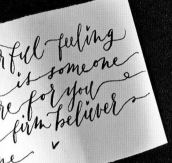

LITTLE SPOOL
OF LOVE

I'm a hopeless romantic at heart, and I created this simple little project to record special, intimate moments we experience with loved ones. What could be more romantic or sentimental than scripting cherished words and wrapping them around a little wooden spool tied up with a beautiful silk ribbon? I chose a favorite quote from the book *P.S. I Love You* by Cecelia Ahern. Wedding vows, love notes, or other meaningful messages would also make wonderful scrolls.

SUPPLIES

2³/4" (7 CM) WOODEN SPOOL

SEPIA BROWN INK:
*DALER-ROWNEY FW ACRYLIC
ARTISTS INK*

SIZE 12 ROUND WATERCOLOR
BRUSH

JAR OF WATER (TO DILUTE INK
AND CLEAN NIB)

9" X 12" (23 X 30.5 CM)
TRANSLUCENT MARKER PAPER:
CANSON PRO LAYOUT MARKER

PENCIL AND ERASER

RULER

BLACK CALLIGRAPHY INK:
WINSOR & NEWTON

CALLIGRAPHY NIB AND HOLDER:
SPEEDBALL OBLIQUE HOLDER
WITH *HUNT 22* VINTAGE NIB

DAPPEN DISH

PAPER TRIMMER OR SCISSORS

ADHESIVE RUNNER

1/2–11/2" (1.3–3.8 CM) WIDE SILK
RIBBON, 6–8" (15–20.5 CM) LONG

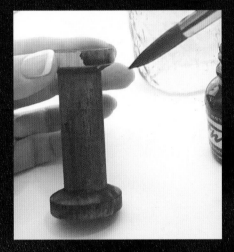

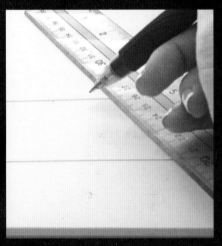

Stain the Spool

1 With a watercolor brush, apply sepia brown ink to all exterior surfaces of the spool. To create a more translucent color, first dip the brush in water. Set the spool aside to dry. Apply additional layers for a darker stain.

Measure the Paper Strip

2 With a ruler and pencil, draw a line the full length of the marker paper. Measure 2" (5 cm) from the first line and draw a second line parallel to the first line to create a 2" x 11" (5 x 28 cm) long strip.

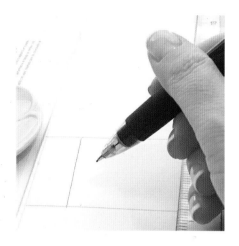

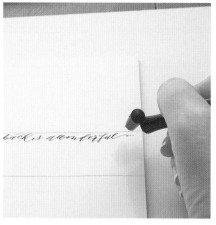

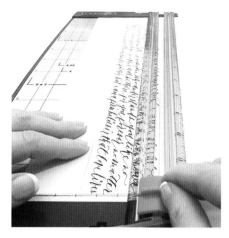

Script the Scroll

3 Draw a vertical line between the two parallel lines about 1" (2.5 cm) from the left edge of the paper. This space will be reserved for attaching the paper to the wooden spool.

4 To the right of the vertical line, script your text in pen and ink the full length of the strip. Once completed, allow the ink to dry thoroughly.

Cut the Paper Strip

5 Remove the sheet of paper from the pad. With a paper trimmer or scissors, cut along the designated horizontal lines to create the paper strip for the scroll. Erase any pencil markings.

TIP ❯ **If you're concerned about spacing and layout, practice writing the quote in pencil on a sample piece of paper marked with the same dimensions. Place it under the marker paper to use as a general guide.**

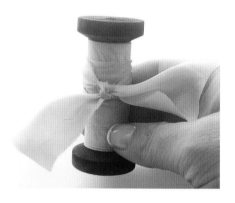

Assemble the Spool

6 Roll adhesive along the left edge of the horizontal strip on the lettering side of the paper. Adhere the paper to the wooden spool. Make sure the paper is aligned horizontally to the spool so it will wrap evenly.

7 Once the paper has been properly adhered to the spool, begin rolling the paper around the spool.

8 Tie the ribbon around the spool to hold the scroll in place and add a decorative touch.

VARIATIONS

❥ **Paint the spool in a more colorful hue.**

❥ **Wrap a note around a toy rattle and give it as a shower gift or favor.**

❥ **Place the scroll in a small bottle and tie with a ribbon.**

MAKE-YOUR-OWN
TATTOOS

What better way to show off your lettering than by sporting your own personal tattoo? Print the tattoos yourself or have them printed for a more professional look. There is a variety of colors available, including white and metallics. And because these tattoos aren't permanent, you can change them to match your every mood or outfit!

SUPPLIES

COPY PAPER

PENCIL AND ERASER

9" X 12" (23 X 30.5 CM)
TRANSLUCENT MARKER PAPER:
CANSON PRO LAYOUT MARKER

CALLIGRAPHY NIB AND HOLDER:
GENERAL'S CORK-TIPPED PEN
HOLDER AND *NIKKO G* NIB

BLACK CALLIGRAPHY INK: *WINSOR &
NEWTON*

DAPPEN DISH

JAR OF WATER (FOR CLEANING NIB)

COMPUTER AND SCANNER

ADOBE PHOTOSHOP OR *ILLUSTRATOR*

PRINTABLE TATTOO PAPER:
SILHOUETTE (OPTIONAL)

INKJET PRINTER (OPTIONAL)

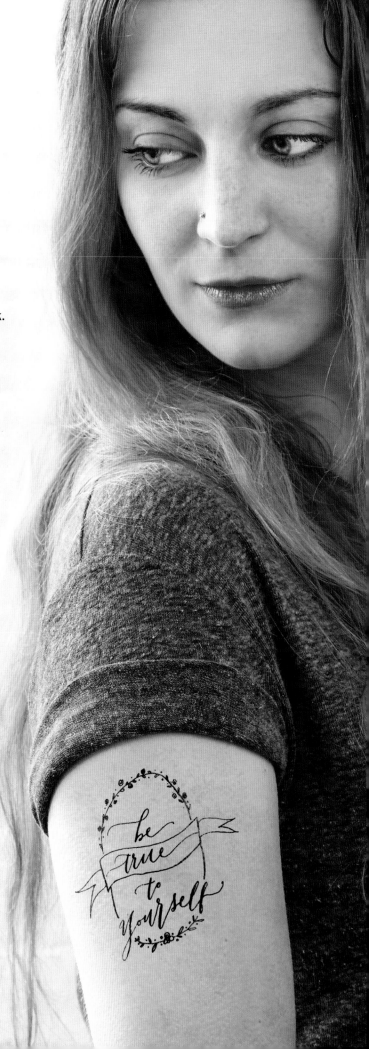

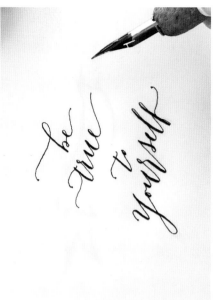

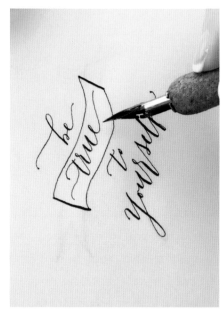

Ink the Design

1 To work out your design, draw small "thumbnail" sketches on plain copy paper with pencil. Once you have a design you like, redraw it in pencil at the actual size you'd like the tattoo to be.

2 Lay a sheet of marker paper onto the pencil-drawn design. With a dip pen and ink, script the words using the penciled design as a placement guide.

3 Next, ink the banner embellishment with the pen and ink.

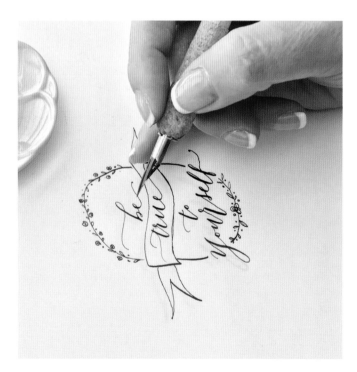

4 Add additional embellishments to the design. I added a circular design with leaves and flowers. Once you're satisfied with the design, digitize it using Photoshop or Illustrator. (See page 125 for instructions.) See Printing the Tattoos on the opposite page for options for printing your tattoo.

VARIATIONS

❧ **Print your designs on adhesive paper to create your own stickers.**

❧ **Design tattoos for family reunions, parties, and other gatherings.**

❧ **Print your design on labels to add a nice touch to party favors for baby showers, wedding receptions, and other social events.**

PRINTING THE TATTOOS

There are two options for getting your tattoo printed: printing it onto printable tattoo paper with an inkjet printer or uploading your design to an online temporary-tattoo manufacturer.

Printing your design yourself is a convenient and inexpensive way to print tattoos. You can print designs in a multitude of colors. One drawback is that an inkjet printer will not print white. To print your design, follow the instructions provided with the paper.

An online vendor can print your tattoo in white ink and metallic foils, and the quality is better. However, this option may be a bit costly and you will be dependent upon the manufacturer's process and shipping time.

If you decide to use an online vendor to print your tattoo, follow the artwork specifications and upload directions on their website. Online vendors are listed in the Resources on page 133.

DESIGN IDEAS

Here are a few tattoo designs to try or to use as inspiration. Depending on how you print the tattoos, they can be in different colors, even metallics and white. Size the tattoo to fit where you want to apply it.

love

bravery

follow your heart

be true to yourself

GOLD MONOGRAM
LOCKET

A simple letter is elevated with the use of gold mica watercolor paint combined with translucent vellum. It is an elegant and timeless design. If you haven't used mica watercolors before, you will fall in love with these paints. They come in various metallic colors and simply glide onto the smooth vellum, making this charming pendant the perfect project for a beginner calligrapher.

SUPPLIES

VELLUM PAPER

1" (2.5 CM) PAPER PUNCH

FINETEC ARTIST MICA WATERCOLOR IN FINE GOLD

JAR OF WATER

CALLIGRAPHY NIB AND HOLDER: *E+M* CORK-TIPPED PEN HOLDER WITH *HUNT 22* VINTAGE NIB

SIZE 4 ROUND WATERCOLOR BRUSH

1" (2.5 CM) CIRCULAR CLEAR-GLASS LOCKET

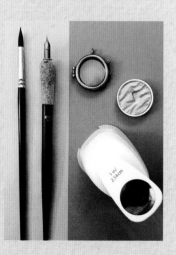

Cut Paper into Circles

1 Using a 1" (2.5 cm) paper punch, cut the vellum paper into 1" circles. Punch extra circles to practice your lettering.

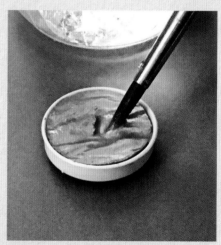

Prepare the Watercolor

2 Wet the watercolor pan with a few drops of warm water. Mix the water with a watercolor brush.

TIP ❯ If you're unable to find a 1" (2.5 cm) circle locket or have a different size or shape locket you'd like to use, just cut the vellum paper to the appropriate size and shape.

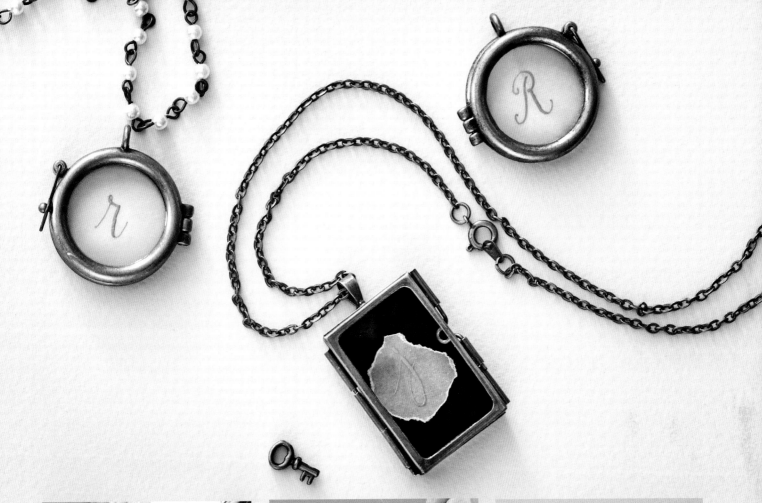

Script Your Letter

3 Load the nib with the watercolor using a watercolor brush. Test that the paint is flowing through the pen nib by pressing the tip of the nib on a scrap piece of paper.

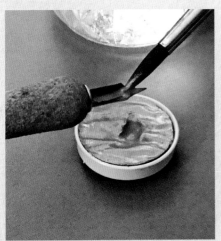

4 Script your letter in the center of the circle. Experiment with different versions of the letter. Allow the ink to dry completely.

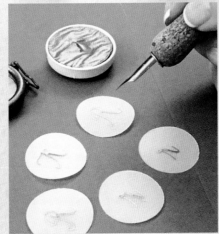

Assemble the Locket

5 Select your favorite version of the letter you scripted. Open the locket, place the piece of paper inside, and lock securely.

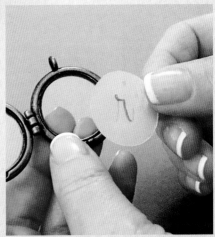

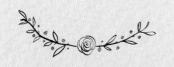

VARIATIONS

❦ For a vintage look, tear the paper to create a deckled edge and place it in the locket.

❦ If your locket is large enough, letter a short name or three-letter mongram.

❦ If you use an opaque paper instead of the vellum, you could insert a photo to show through the other side for a reversible pendant.

ARTFUL
BUSINESS CARDS

If you're a creative professional, what better way to promote your business than with a custom business card you design yourself? For my own business card, which I'm using as an example here, I combined my love of calligraphy and my passion for abstract art by using one of my signature paintings as a backdrop to my calligraphy. As a creative entrepreneur, I also chose a square-shaped format, which is a little different than the standard business-card rectangle.

SUPPLIES

PENCIL AND ERASER

COPY PAPER

CALLIGRAPHY NIB AND HOLDER:
GENERAL'S CORK-TIPPED PEN HOLDER AND NIKKO G NIB

CALLIGRAPHY INK IN BLACK:
WINSOR & NEWTON

JAR OF WATER
(FOR CLEANING NIB)

9" X 12" (23 X 30.5 CM)
TRANSLUCENT MARKER PAPER:
CANSON PRO LAYOUT MARKER

SCANNER AND COMPUTER

ADOBE PHOTOSHOP

SCANNED IMAGE FOR
BACKGROUND (OPTIONAL)

CARD STOCK (65 LB. OR
HEAVIER) FOR PRINTING YOUR
OWN CARDS (OPTIONAL)

Design the Layout

1 With a pencil and copy paper, create thumbnail drawings showing the various components. Besides the text you'll be lettering, include other pertinent information, such as phone number, email, and client services. Remember that you can use both sides of the card. With your dip pen and black ink, write several versions of the business name on translucent marker paper.

. .

TIP ❯ **If you're creating a card for a friend or client, get an understanding of their business, what they do, and what they want to convey to their customers.**

. .

Digitize the Design

2 Once you're satisfied with the lettering, scan your design and digitize it using Photoshop. See page 125 for step-by-step instructions.

VARIATIONS

♥ The printing company will probably offer ways to add pizzazz to your business card designs, such as printing your hand lettering in gold foil or spot gloss (a shiny, smooth accent against a matte background).

♥ Clear plastic is a popular material for business cards! You could choose to have your lettering read clear against a dark background or vice versa.

♥ Design a "Mom" (or "Dad") card to hand out to other parents to exchange contact information for play dates.

♥ Create cards for a bride and groom to share their website, social hashtags, and helpful information with wedding guests.

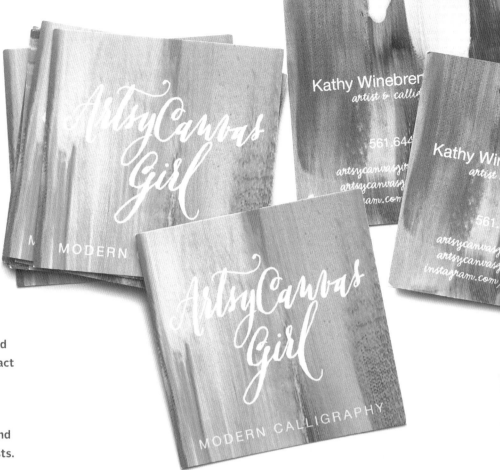

Design and Print the Card

3 Whether you'll be printing the cards on a home printer or with a professional printing service (see Resources on page 133 for companies that print business cards), you'll need to know the file specifications. Based on these specifications, create a new file in Photoshop. I created a file that is 3 1/8" x 3 1/8" (8 x 8 cm) and set up guidelines of 1/4" (6 mm) on each side to ensure that none of the text would get cropped.

4 In my example, I used the Place command to bring in the background image and digitized lettering. (I converted my lettering to white; see Step 15 on page 130 for instructions.) Design both the front and the back of the card. Upload the file to your printer using the website's instructions or print it on your home printer.

"There are only four questions of value in life . . . :
What is sacred?
Of what is the spirit made?
What is worth living for?
And what is worth dying for?
The answer to each is the same. Only love."

—Lenore Fleischer, *Don Juan DeMarco*

PHOTO
WORD ART

Digitally merging lettering and a photograph creates a unique image you can print and display in any number of ways. You may fall in love with a special phrase from a song or movie and then search for the perfect photo to match the words, or you may be inspired by a beautiful photo and search for just the right words to complement it. I knew I wanted to use this favorite photo of my daughter, and I loved how the wisdom of the quote reflected the innocence of her face.

SUPPLIES

DIGITAL PHOTOGRAPH

COPY PAPER

COMPUTER

PRINTER

9" X 12" (23 X 30.5 CM) TRANSLUCENT MARKER PAPER: *CANSON PRO LAYOUT MARKER*

PENCIL AND ERASER

CALLIGRAPHY INK IN BLACK: *WINSOR & NEWTON*

CALLIGRAPHY NIB AND HOLDER: *GENERAL'S* CORK-TIPPED PEN HOLDER AND *NIKKO G NIB*

JAR OF WATER (FOR CLEANING NIB)

DAPPEN DISH

SCANNER

ADOBE PHOTOSHOP

ADOBE ILLUSTRATOR (OPTIONAL)

PHOTO PAPER: *HP PREMIUM*

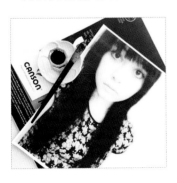

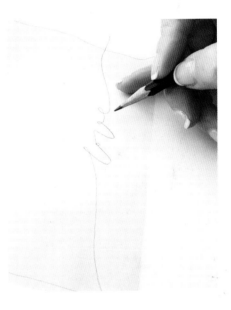

Create the Design

1 Choose an image and print the photo onto copy paper at the size you would like the final image to be. I decided to crop the image and focus on just the face.

. .

TIP ❯ **When selecting the photo, make sure it has enough space to accommodate the length of your words.**

. .

2 Lay a sheet of marker paper over the photo. Next, with a pencil, block in the shape in which you want the text to be placed. Because I knew I wanted the word *love* to flow across her lips, I penciled that in first.

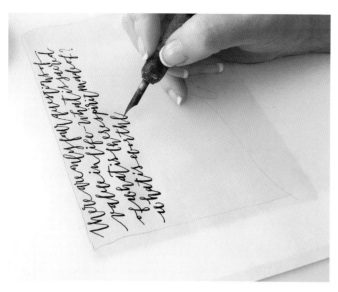

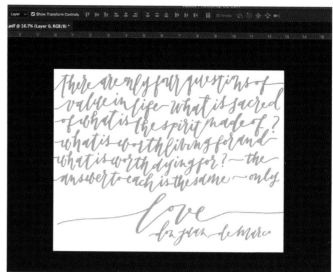

Script the Lettering

3 Script the words using pen and ink and the pencil guide for placement. If you're concerned about spacing and layout, practice writing the quote in pencil on a sample piece of paper using the same dimensions. When you're happy with the layout, use it as a guide by placing the pencil-drawn layout underneath the marker paper.

. .

TIP › **I keep a journal of favorite quotes from books and movies, inspirational quotes I find on the Internet, or original thoughts of my own. When I feel inspired, I select a few different quotes to play around with.**

. .

VARIATIONS

❦ **Have your artwork printed onto canvas.**

❦ **A number of online retailers will print your image on coffee mugs, puzzles, tote bags, and other gift items. See Resources on page 133 for suggestions.**

❦ **Create a special gift for new parents or newlyweds with a special photo.**

❦ **Landscapes and urban scenes make wonderful backdrops for lettering.**

Create the Design

4 Scan the design and digitize the design using Photoshop or Illustrator. See page 125 for step-by-step instructions. If you will be resizing a smaller photo to larger than a 5" x 7" (12.5 x 18 cm), I recommend digitizing the lettering in Adobe Illustrator to ensure a good resolution.

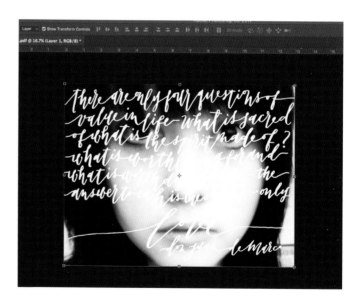

Merge the Lettering and Photo

5 Open the digitized photo in Adobe Photoshop. Next, select the Place command to bring the lettering file into the image file. (I first converted my lettering to white; see Step 15 on page 130 for instructions.) Size and position the lettering to fit the design of your layout. When you're satisfied with your image, print it onto photo paper and frame it.

CUSTOM
COCKTAIL STIRRERS

Pick a theme for your party and create drink stirrers that coordinate with your decorations, napkins, and other supplies. They're a fun and simple way to add a personal touch. Treat sticks are available in various lengths, so choose ones that will work with the glasses you're using. I scripted with white ink on dark paper here, but feel free to use other ink and paper colors to coordinate with your party theme or color scheme.

SUPPLIES

SOLID OR PRINTED PAPERS

PAPER TRIMMER OR SCISSORS

WHITE INK: *DR. PH. MARTIN'S BLEED PROOF WHITE*

GUM ARABIC

DROPPER

SMALL STICK (FOR MIXING INK)

DAPPEN DISH

CALLIGRAPHY NIB AND HOLDER: *E+M CORK-TIPPED PEN HOLDER AND HUNT 22 VINTAGE NIB*

JAR OF WATER (FOR CLEANING NIB)

TREAT STICKS

ADHESIVE RUNNER TAPE

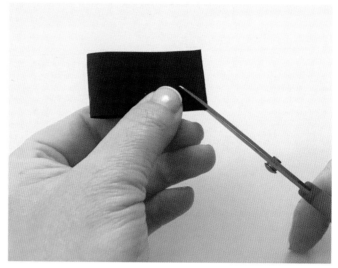

Cut Paper into Banners

1 Using a paper trimmer, cut the paper into 1" (2.5 cm) strips. Then cut the strips into 4" (10 cm) long pieces.

2 Next, fold the 4" (10 cm) piece of paper in half, bringing the two ends together. With scissors, cut a small triangle off the right edge of the paper to create a "swallowtail" edge.

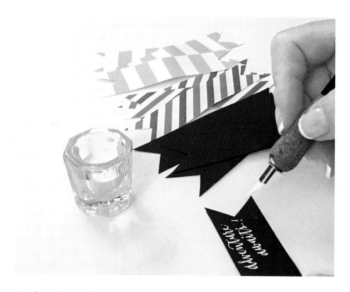

Script Your Message

3 Begin scripting fun phrases using the Bleed Proof White mixture (see Preparing White Ink at right) or the ink of your choice. The banner will be folded in half. You can letter on one or both sides. Just make sure that the phrases will be legible when the banner is folded and adhered to the treat stick and that the lettering is facing the right direction. Let the ink dry thoroughly.

T I P ❯ **If the white ink gets clogged in your pen, dip the tip in water, then test it on scrap paper. This will usually jump-start the flow of the fluid.**

PREPARING WHITE INK

Dr. Ph. Martin's Bleed Proof White is an opaque white watercolor originally made for covering mistakes. Calligraphers have found this to be a wonderful product to use on dark papers. However, to use this product in a dip pen, it needs to be diluted due to its thick consistency. Fill your dappen dish or small jar with the white fluid, leaving room to add a small amount of water. With a water dropper, add a few drops of water. Mix and then test the mixture by writing with your dip pen. Continue adding drops of water until the white fluid is thinned out enough to flow through the dip pen. Once you've reached the right consistency, add a small amount of gum arabic to the mixture. Stir until the gum arabic has been full absorbed in the water.

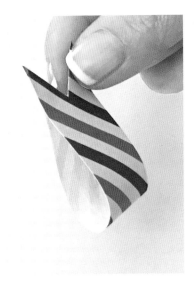

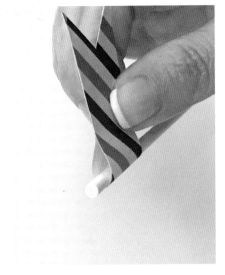

Assemble the Stirrers

4 Place adhesive on the back of the banner using the tape runner.

5 Match the two ends and press them together, leaving a space near the center fold for the treat stick.

6 Place the treat stick into the center fold of the banner.

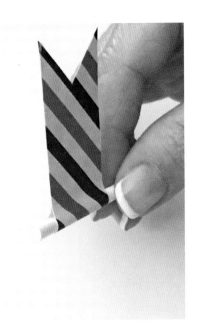

7 Continue to press the paper together until you reach the treat stick. The paper will be attached to the treat stick and look like a mini flag.

VARIATIONS

♥ **For a cocktail party, write guests' names on stirrers so they won't lose their drinks.**

♥ **Write ice-breaker prompts on stirrers to get the conversation rolling.**

♥ **Create decorative cake toppers with appropriate phrases. You can even write single words on individual flags and group them to spell a message, such as "Happy Birthday."**

LETTERED
LOGO STAMP

Creating custom stamps is a wonderful, very visible way to show off your lettering. Stamps can be used in so many practical and creative ways: for paperwork, journaling, return addresses, or to imprint a business logo and address on packaging. For this project, I created a logo for my calligraphy business. I love that I can use it over and over and even change the ink color for variety. Designing a stamp and having it made couldn't be easier.

SUPPLIES

COPY PAPER (OPTIONAL)

PENCIL AND ERASER

9" X 12" (23 X 30.5 CM) NON-
BLEEDABLE TRANSLUCENT
MARKER PAPER: *CANSON PRO
LAYOUT MARKER*

CALLIGRAPHY NIB AND HOLDER:
*E+M CORK-TIPPED HOLDER WITH
HUNT 22 VINTAGE NIB*

BLACK CALLIGRAPHY INK:
WINSOR & NEWTON

JAR OF WATER (FOR CLEANING
NIB)

COMPUTER AND SCANNER

ADOBE PHOTOSHOP

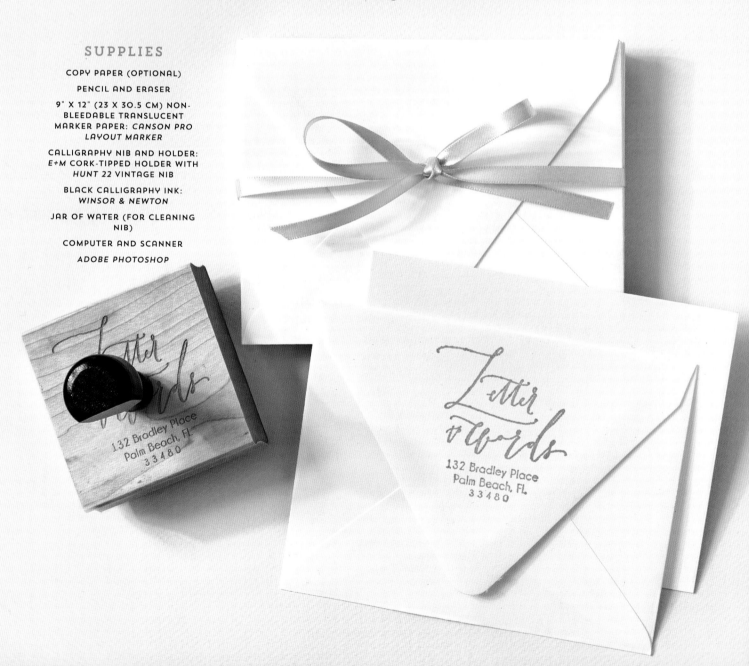

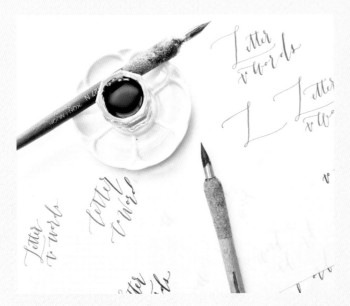

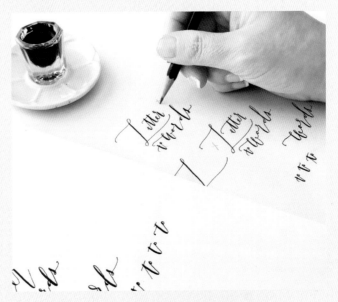

Create the Design

1 Begin writing your words in pencil on copy paper or with your pen on marker paper to help create your design. I tried out a couple different pens to see which effect I like best.

2 Review the letters and words from Step 1. Designate the words or letters you like with a small *x* or check mark. Create your final lettering on marker paper with the pen and black ink.

Digitize the Design

3 Scan the lettering and digitize it using Photoshop. See page 125 for step-by-step instructions. Add the address if desired. I used the font Champagne & Limousines. Create a file to upload to an online vendor. (See Resources on page 133 for suggestions.) Check their website for file specifications, which are usually determined by the size of the stamp.

VARIATIONS

♥ Design a stamp to use on holiday cards and packages.

♥ Create a stamp with your name or a child's name to label belongings.

♥ If you have a small business such as an Etsy shop, make a shipping stamp that says DO NOT BEND, HANDLE WITH CARE, or MADE ESPECIALLY FOR YOU.

♥ Design a simple monogram stamp.

♥ Create a stamp for journaling with a phrase like "Today I am _____" or a favorite inspirational quote.

♥ A return address stamp would make a thoughtful housewarming gift.

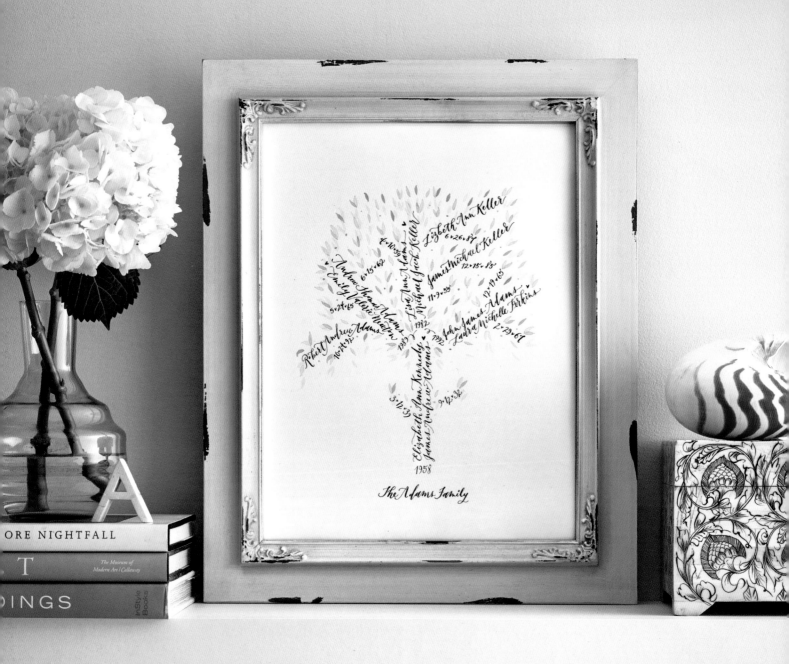

The Adams Family

BRILLIANT: WHITE IN DESIGN

The Art of Frederick Sommer
PHOTOGRAPHY, DRAWING, COLLAGE

Terence Conran The Essential House Book

HEIRLOOM
FAMILY TREE

Lettering a family tree is a decorative and creative way to record your family's heritage, and this project makes a great gift and memorable keepsake. If you don't already know all your family's names and important dates, it's a wonderful opportunity to catch up with loved ones and elicit memories from older relatives. Your completed family tree will serve as a constant reminder of these special times.

SUPPLIES

COPY PAPER

HB OR 2B PENCIL

ERASER

140-LB. HOT-PRESS
WATERCOLOR PAPER

LIGHTPAD (OPTIONAL)

CALLIGRAPHY NIB AND HOLDER:
*E+M CORK-TIPPED HOLDER WITH
HUNT 22 VINTAGE NIB*

BROWN INK: *DALER-ROWNEY FW
ACRYLIC ARTISTS INK IN
ANTELOPE BROWN*

WATER DROPPER OR PIPETTE
(OPTIONAL)

JAR OF WATER

GUM ARABIC (OPTIONAL)

PAPER TRIMMER

SEVERAL SHADES OF GREEN
WATERCOLORS: *DANIEL SMITH
EXTRA FINE WATERCOLORS
IN FUCHSITE GENUINE AND
WINSOR & NEWTON IN SAP
GREEN AND HOOKER'S GREEN*

SMALL ROUND WATERCOLOR
BRUSH: *PRINCETON MINI
DETAILER, SIZE 3/0*

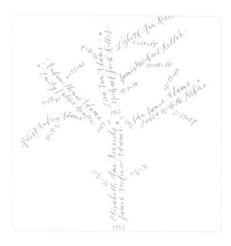

Design the Layout

1 On copy paper, sketch out the family tree to be used as a reference. I kept mine fairly simple, including just three generations with their birth dates.

Ink in the Names

2 Make a copy of your sketch. Use the original to ensure the correct dates and spelling of names and the copy as a design reference. Layer the design reference under watercolor paper on the lightpad. Lightly pencil the tree with lines representing the trunk and branches.

. .

TIP ⟩ Before I had a lightpad to use for tracing, I placed a lamp under my glass-top dining table.

. .

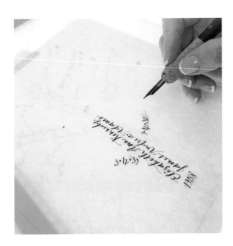

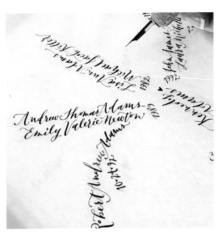

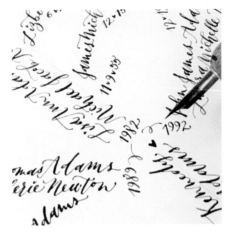

3 With the calligraphy pen and brown ink, begin inking the names and dates. Start at the bottom and work your way up the trunk.

4 Continue inking the lettering in the branches and top of the tree. Be careful of the wet areas as you work.

5 Continue until all names and dates are inked in. Add embellishments to fill in gaps or add detail. I used hearts near names and added swirls where the three main branches meet the trunk.

TIP ⟩ **If you get to a point in which the angle is difficult to script because it's near a wet area, take a coffee break to allow the areas to dry.**

INSTANT ANTIQUE

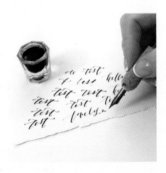

You can use the deep brown ink right out of the bottle, but for a more Old-World style suited to a future family heirloom, dilute the ink to make it more translucent. Mix the ink with water in a one-to-one ratio in a glass jar. Test the color on a scrap piece of watercolor paper. Let it dry completely to see the final color. Adjust based on your preference. Once you're satisfied, add a small amount of gum arabic. This will give the lettering a crisper edge. Stir until the gum arabic has been fully absorbed by the water.

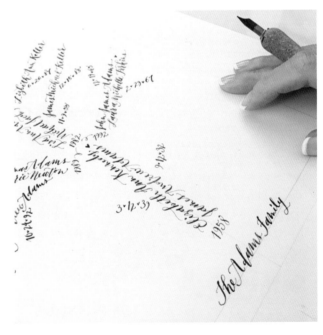

6 Draw a line centered underneath the base of the family tree trunk. Script the family name.

COLOR SWATCHING

To decide which colors you want to use when working with watercolors, create swatches of each color by painting a small rectangle shape on a scrap piece of the same watercolor paper you'll be using. If you're working with more than one color, mix them on your palette with your brush. Create swatches of colors until you find the right mix. Be sure to note the names of the paint as well as the paint ratio for any colors created from a mixture so you can easily recreate the color.

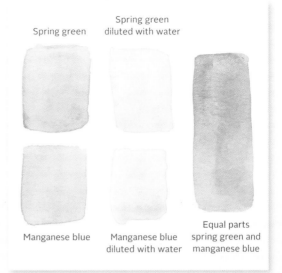

Spring green

Spring green diluted with water

Manganese blue

Manganese blue diluted with water

Equal parts spring green and manganese blue

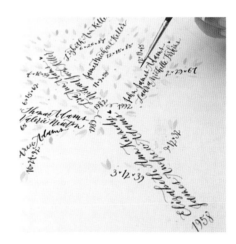

Embellish the Tree with Leaves

7 Before you begin painting, take a moment to select the colors for the leaves. See Color Swatching (above). I used three different shades. Wet the paints with a few drops of warm water and create a leaf by painting two small arches with the tip of a small round watercolor brush. Fill in the shape with paint. Begin by painting leaves in one color randomly around the branches.

8 Begin painting leaves in a second color. Create variety by grouping some leaves together. Paint some single leaves floating among the branches. Repeat this process with the third shade of green. Fill the gaps between the branches with simple leaves.

VARIATION

♥ After you've completed a simple family tree like this one, you might be inspired to create a larger version with more generations and dates.

DESIGN-IT-YOURSELF
FABRIC

Designing your own fabric is a fun way to share your lettering with others or to incorporate your lettering into your craft projects. Before you get started, decide on the elements you want to use, keeping in mind that the design will be repeated. Here I'm using a calligraphic phrase I previously scanned and a scanned watercolor swatch to color the lettering. I used the swatch to create a custom pattern in Photoshop that gives the lettering a subtle gradation effect.

SUPPLIES

ADOBE PHOTOSHOP

DIGITIZED ARTWORK:
CALLIGRAPHIC PHRASE AND
WATERCOLOR BACKGROUND

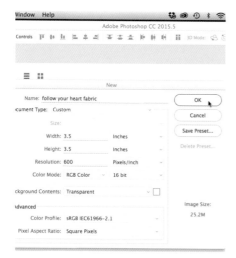
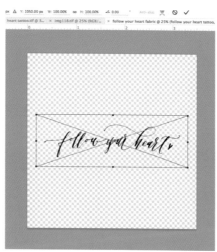
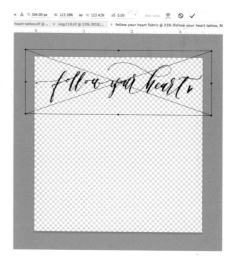

Create and Open Your Files

1 In Photoshop, create a new file to contain the fabric design. Select the dimensions of the file. I created a 3^1/$_2$" x 3^1/$_2$" (9 x 9 cm) square with a transparent background. Click OK. I named the file "follow your heart fabric."

Place Your Art

2 Next, bring in your lettering by selecting File > Place Linked. Navigate to where your digitized lettering is located and select the file, then click the Place button. Hit Enter and the image is now in the center of the file.

3 With the Move tool selected, move the image up. Then resize the image to fill the space by selecting one of the corner anchors. Press the Shift key while pulling on the anchor to ensure that the image keeps its proportions.

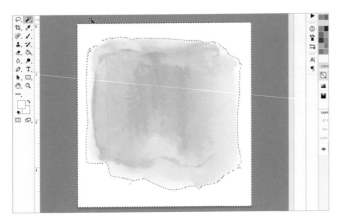 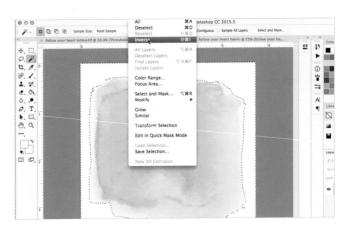

Clean Up the Watercolor Swatch

4 Open the file containing the watercolor swatch and select the Magic Wand tool from the Toolbar. Click on the outer white section. This will select all the white within the image.

5 From the Application Bar, click on Select > Inverse to select any part of the image that is not white (basically the watercolor swatch excluding the white background).

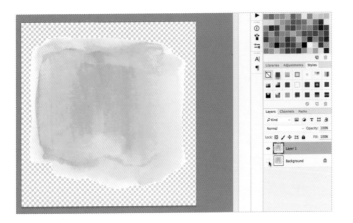 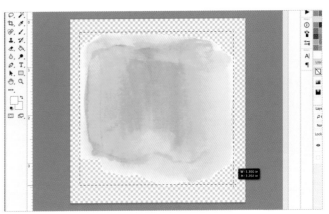

6 Select Layer > New > Layer Via Copy. This will create a layer with only the swatch. Turn off the background layer by clicking on the "eye" icon next to the layer.

Make a User-Defined Pattern

7 Select the Rectangle Marquee tool from the toolbar. Drag the cursor across the image, encapsulating the swatch.

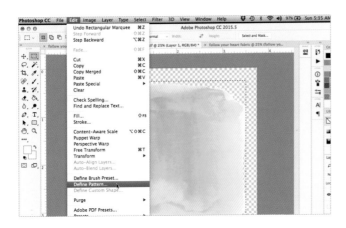 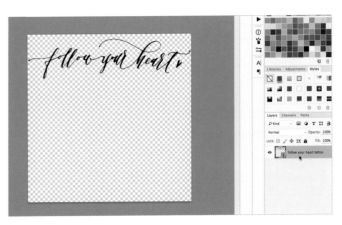

8 Select Edit > Define Pattern. This will save the image selected by the Marquee tool as a user-defined pattern (as opposed to a predefined pattern in Photoshop).

Apply Color Swatch to Lettering

9 Select the window containing the phrase.

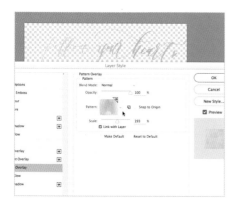

Create a Seamless Pattern

10 Double-click on the layer to bring up the Layer Style dialog box. Click the box next to Pattern Overlay listed under Styles. Check to see that the pattern defaulted to the last user-defined pattern created, the watercolor swatch. If it didn't, click on the arrow to the right of the swatch to allow you to select the pattern of your choice. You can change the scale of the pattern by typing in a value or using the slider. When you're happy with the selection, click the OK button.

11 Now that you have the word phrase created in a way that you like it, make a copy of it by selecting Layer > New > Layer Via Copy. Now move the new layer down below the original layer by selecting the Move tool from the toolbar.

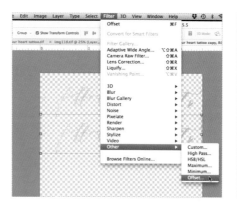

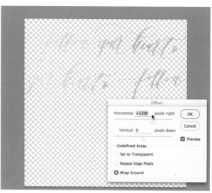

12 To create interest in the pattern layout, we will offset the lettering. (See Offsetting Your Lettering below.) Click on Filter > Other > Offset.

13 Make sure you have selected the copy layer when applying the Offset command. Enter 1200 next to Horizontal to move the image to the right 1200 pixels.

Test Pattern Design

14 Select the Rectangle Marquee tool from the toolbar. Drag your cursor across the image, encapsulating what will be repeated in the pattern.

OFFSETTING YOUR LETTERING

Using the Offset filter in Photoshop is an easy way to create seamless patterns. This filter offsets the image horizontally or vertically based on the settings you provide. Specific to my design, I chose to offset the image horizontally by 1200 pixels because I liked how the embellished ascender of the letter *H* intertwined with the descender loop of the letter *F* from the image above. If you're interested in an even horizontal offset, just calculate the offset by taking the width of the image in pixels and then dividing by two.

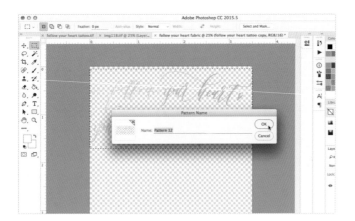

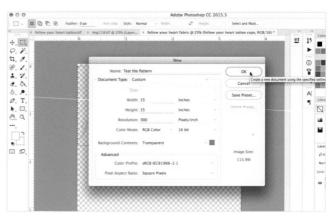

15 Select Edit > Define Pattern. The Pattern Name dialog box will appear; use the default pattern name. In this instance, it is Pattern 12.

16 Now create a new file with dimensions larger than the pattern size. You want to see the pattern repeat a couple of times. I chose to create a 15" x 15" (38 x 38 cm) image with a transparent background.

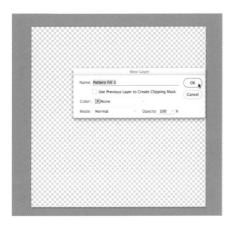

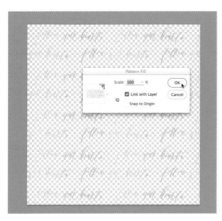

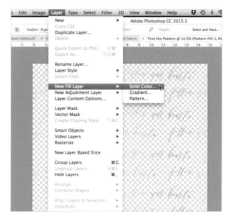

17 To test the pattern, select Layer > New Fill Layer > Pattern. A New Layer dialog box will appear. Click OK. Next, a Pattern Fill dialog box will appear.

18 The default pattern should be the most recently created user-defined pattern. You can also select a specific pattern by clicking on the arrow next to the pattern image.

19 The design may be a bit hard to see against the transparent background. Create a new layer by selecting Layer > New Fill Layer > Solid Color.

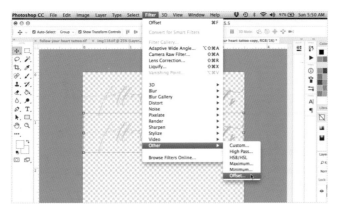

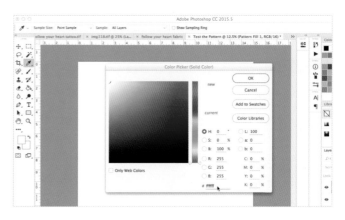

20 A New Layer dialog box appears. Click OK.

21 A Color Picker dialog box appears. At the bottom of the dialog box, enter the hex code for white (ffffff) next to the pound sign and click OK.

Crop Your Design and Save

22 Move the layer below the pattern layer by grabbing the layer while pressing down on the mouse. You should be able to see the pattern design well enough to see whether there are any issues with your design.

23 If you're happy with the test, switch back to the fabric file. Your selection from the Rectangle Marquee tool should still be highlighted. Select the Crop tool from the toolbar. The file will be cropped to the marquee selection. Save the file as a TIFF, JPEG, PNG, or GIF file. Upload your fabric to an online fabric printer (see Resources on page 133 for suggestions). I used Spoonflower.

VARIATIONS

♥ **Not only can you create fabric through Spoonflower, but you can also create wallpaper and wrapping paper.**

♥ **A fun project is to create a list of words that fall under one theme. Digitize them and place them together like pieces of a puzzle, creating a repeat for fabric, gift paper, or wallpaper.**

♥ **My sister created the sweet bags shown here using my custom fabric. You can use your fabric in so many ways—in a quilt, pillows, clothing, and many more projects.**

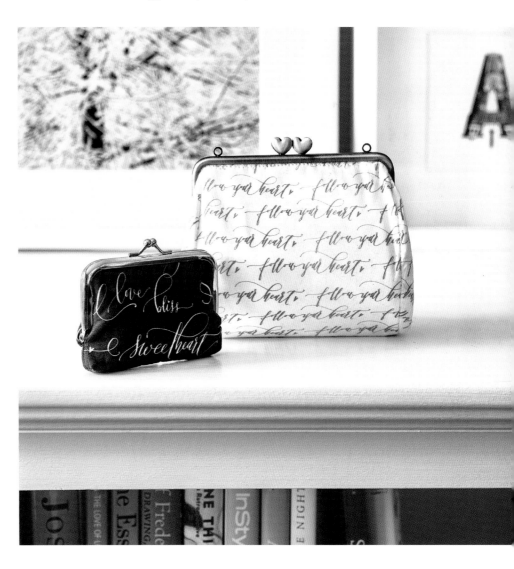

brush lettering

BRUSH LETTERING is a lot like modern calligraphy in that the letters are also created with strokes. Instead of using a pointed pen, you form the strokes with the bristles of a brush. With calligraphy, you're limited by the size of the nib and the mediums it can hold, but brush lettering opens up creative possibilities for using different mediums and for creating larger letterforms. In this section, I will go over additional supplies you can use for brush lettering, the basics of forming strokes, ways to vary your lettering, and more. Creative projects that incorporate brush lettering round out the chapter.

TOOLS AND MATERIALS

To start brush lettering, you only need a few items: a brush, paper, and ink or another medium. You can use some of the same supplies as for calligraphy (see page 12). Here are some additional tools and materials you'll want to add to your stash.

BRUSHES AND MARKERS

There is a wide variety of brushes and markers you can use to brush letter. I group the tools into three categories: water brushes, paintbrushes, and brush markers.

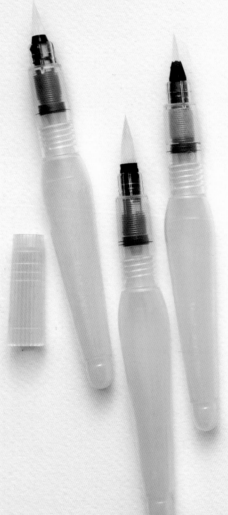

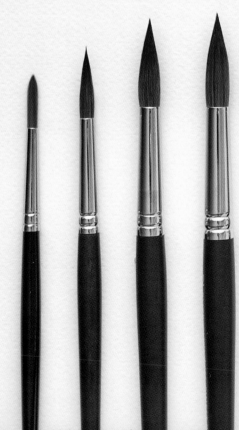

Felt-Tip Brush Markers

Different from a standard felt-tip marker, this marker has an elongated tip that tapers to a point. The felt tip can be manipulated in a similar way to a brush by using the tip for the light upstroke. For the downstroke, simply use more of the body of the brush tip to create a wider stroke. (See Basic Strokes on page 60.) This type of brush marker is different than the markers referred to under Water Brushes. I use the Tombow Dual Brush Pens.

Paintbrushes

The style and effect you're looking for will determine which brush to use. Typically, I use small round watercolor brushes because they hold the most water. Round brushes will produce script letters similar to modern calligraphy. Flat brushes produce bolder, squared-off lines.

Water Brushes

A water brush, or aqua brush, is a hollow plastic paintbrush with nylon bristles that can be filled with water or ink. This is a good brush for beginners because the bristles are firm and easier to control than a traditional paintbrush. Some manufacturers have created marker sets that are pre-filled with black or colored ink. My favorite water brush is the Pentel Arts Aquash Water Brush. It comes in several sizes.

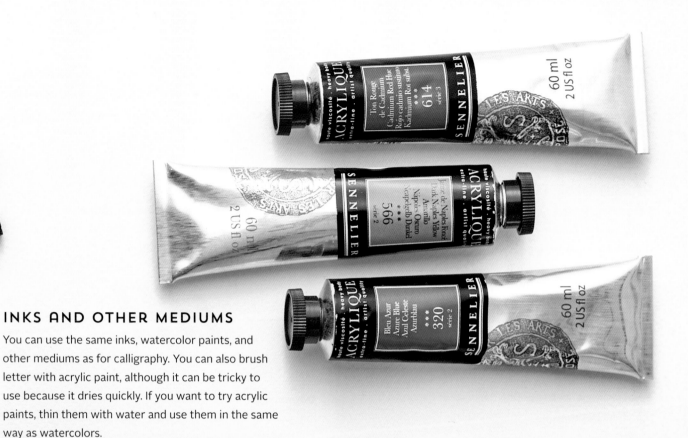

INKS AND OTHER MEDIUMS

You can use the same inks, watercolor paints, and other mediums as for calligraphy. You can also brush letter with acrylic paint, although it can be tricky to use because it dries quickly. If you want to try acrylic paints, thin them with water and use them in the same way as watercolors.

PAPER

Because brush lettering typically uses more water than pointed-pen calligraphy, I tend to use watercolor paper (140 lb. or 300 lb., hot or cold press) or Bristol board, because they are quite absorbent. While it's difficult to do pointed-pen calligraphy on cold-press watercolor paper, because the rough texture makes it harder to control your strokes and it can damage the nib, it works well for brush lettering. As with calligraphy, translucent Canson Pro Layout Marker paper is a good choice for practicing lettering or creating lettering designs that you plan to digitize.

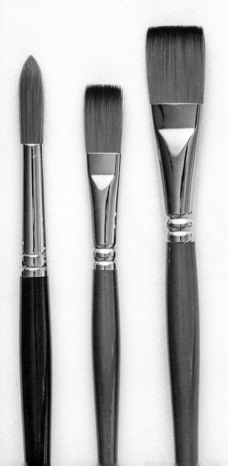

BEGINNER'S TOOLBOX

You need just a few items to get started brush lettering. These are my suggestions for beginners:

Pentel Arts Aquash Water Brush (extra-fine tip)

Higgins Eternal Ink

Canson Pro Layout Marker paper

BRUSH-LETTERING BASICS

Brush lettering is closely related to calligraphy. Basically, you use more of the body of the brush to create the heavy downstrokes and the pointed tip of the brush to create the thin upstrokes.

PREPARING TO BRUSH LETTER

Sit up straight in your chair with your shoulders back. As with calligraphy, it's important to maintain good posture and not slump over when making your strokes. Hold the brush similar to how you hold a pencil. Your fingers should be placed on the band above the bristles. Turn the paper counterclockwise to angle the letters to the right and clockwise for left.

Let's begin by getting comfortable making some marks. Dip your brush into the ink so that the brush is fully wet but not dripping ink. Place a piece of translucent marker paper over the top of your practice sheet (found at the back of the book). Begin making a stroke, moving the point of the brush from the top of the guideline down to the baseline. (See The Anatomy of a Letter on page 18 for helpful terms.)

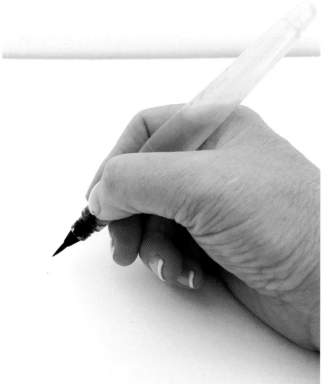

Hold the brush as you would a pencil or calligraphy pen, with your fingers placed on the band.

BASIC STROKES

Whenever I begin brush lettering, I start with these basic strokes to warm up. Mastering these strokes will ensure good muscle-memory control of the brush.

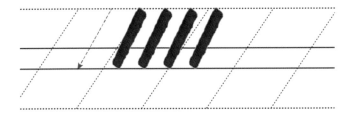

Downstroke

Once you've become comfortable making downward strokes, try using more of the body of the brush in your downstroke to create a thick line. Practice making thick downstrokes with the brush several times until it becomes natural.

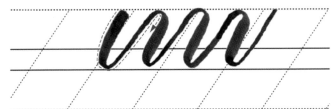

Down Up Stroke

Next, try creating a combination of a thick downstroke and then a thin upstroke by using the tip of the brush when creating the upstroke. See how the brush will work for you in creating thick and thin lines.

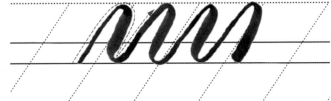

Up Down Stroke

Now try the opposite, starting with the point of the brush for the upstroke and using the body of the brush for the downstroke. Continue practicing these strokes to become comfortable in creating thick and thin lines.

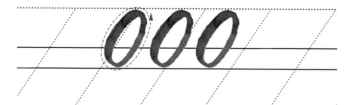

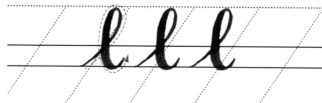

O Stroke

Start at the top of the guideline, a little to the right, with the tip of the brush. As you curve and begin to move down, start using more of the body of the brush in the downstroke. Then begin using less body and more brush tip as you curve around and begin the upstroke. Curve the upstroke and meet the starting point of the letter.

Ascender Loop

Begin by moving the tip of the brush from the baseline to the ascender line in a thin upstroke. Then as you begin to curve around, start applying more of the body of the brush in the downstroke until you reach the baseline. Then curve around, using less body and more tip as you move into your upstroke.

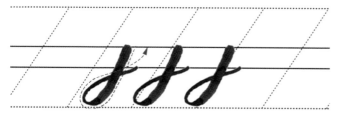

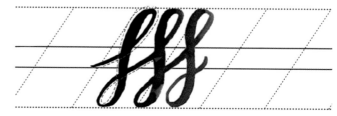

Descender Loop

Starting at the x-height, apply the body of the brush to create a thick line as you move down toward the descender line. As you start to create the curve of the loop, begin using less body and more tip of the brush as you curve around and across the downstroke, ending at the x-height line.

Ascender Descender Combo

Follow the instructions for the ascender loop, then when you reach the baseline continue down to the descender line. Follow the descender loop instructions until you reach the x-height line. Then continue back into the ascender loop instructions.

TIP ❯ **When making ascender and descender strokes, try to keep a light touch so you don't fill in the loops. If your line is too light, you can go back and carefully fill in any skipped spots.**

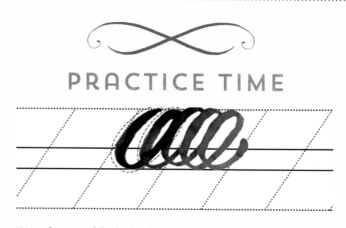

PRACTICE TIME

Warming up with the basic strokes before you begin a brush-lettering project will help you get comfortable with the strokes and controlling the brush and ink. In addition to the basic strokes shown here, I also practice the continuous O stroke.

THE LETTER EXEMPLAR

Now that you know the basic strokes used to create letters, you can begin practicing letters. On the next page, I've provided a letter exemplar that shows one way to create a brush-letter alphabet. A letter exemplar is a complete alphabet that shows a style.

For example, to create the uppercase *A*, follow these steps:

 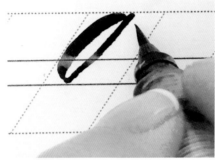 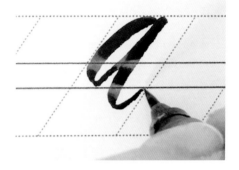

1 Beginning at the ascender line, make a curved downstroke to the baseline.

2 Change direction and make an upstroke that reaches the ascender line.

3 Change direction again and make a downstroke that dips below the baseline, then curves back up, forming a tail.

To create the lower case *a*, follow these steps:

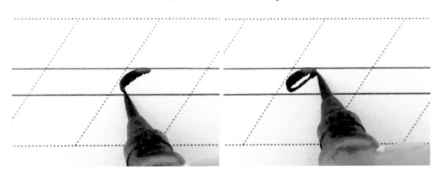 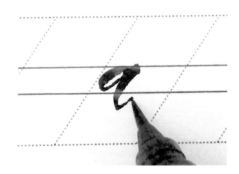

1 Beginning at the x-height, make a rounded downstroke. At the baseline, continue into an upstroke that almost reaches the x-height. This should be done as a single stroke.

2 Make a downstroke from the x-height to slightly below the baseline, ending with a tail.

Begin practicing each letter. You can lay translucent marker paper over the top of the letters (here and on the practice pages at the back of the book) and trace to get started. Then once you become comfortable, try them without tracing.

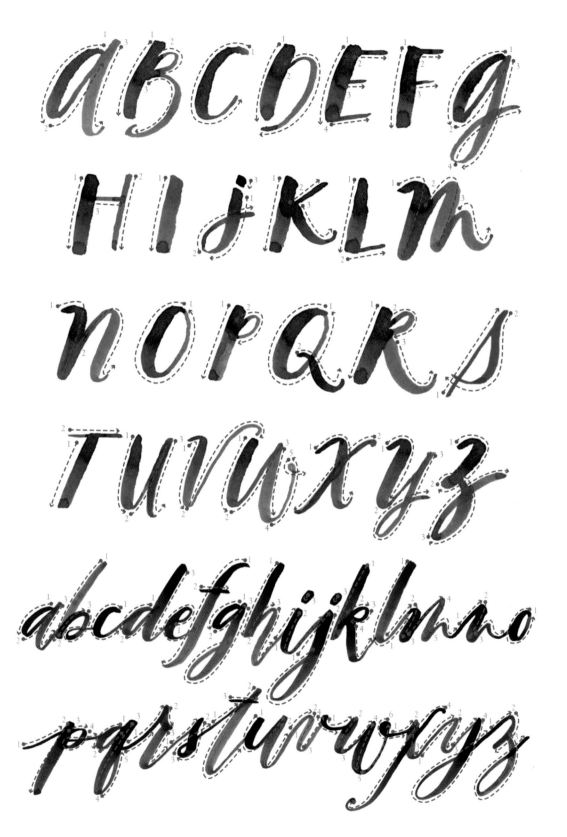

FORMING WORDS

You're now ready to letter words! Most letters end in a downstroke with a slight upstroke at the end of the letter. Continue the ending upstroke into the next letter to create words.

For pleasing word and sentence flow, strive to make each letter slant at the same angle. The slant on the practice sheets is to assist with the slant of the letters. You do not have to slant the letters at a specific angle. A lot of modern brush lettering is written without an angle. The key is to form each letter at the *same* angle. The spacing between the letters will create the visual rhythm of your calligraphy. Generally speaking, the spacing between the letters should be even.

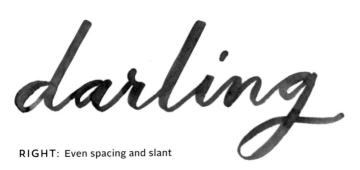

RIGHT: Even spacing and slant

WRONG: Uneven spacing and slant

STYLE VARIATIONS

Here are a few ways to vary basic lettering to consciously change the style. Because brush lettering and modern calligraphy are so similar, you can use many of the same techniques for both (see page 26).

VARIATIONS IN BASELINE

Once you become comfortable with the basic letterforms, you can be more expressive with words by varying the baseline of the word.

VARIATIONS IN SPACING

Another stylized effect can be made by changing the spacing between letters. This will change the rhythm of the style.

NUMBERS AND PUNCTUATION

To letter numbers, use the brush to make thick downstrokes and thin upstokes and transitional curves. Punctuation is functional but can also be a creative design element.

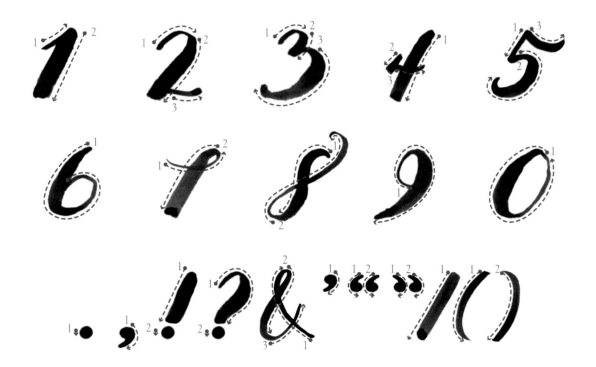

DIY PROJECT DESIGN

The projects that follow demonstrate a number of ways to use brush lettering. You can follow my designs closely or take the techniques and create your own original designs. Here are some strategies I use when working out my designs:

Sketch out the words you want to letter in pencil on copy paper. Once you've come up with several ideas, walk away and come back later with a fresh set of eyes.

Once you're happy with your lettering, you can place it on a lightpad with your project paper on top. Use the pencil version as a guide, but don't try to trace it exactly.

It may be easier to work out your design at a smaller size, and then enlarge it to the final size. See Enlarging Your Drawing on page 104.

If you're working in a specific shape or space, sketch it out first on copy paper so you can make sure your lettering will fit and work well in the space. You can even trace around a piece you plan to letter, such as a gift tag, so you have the exact shape.

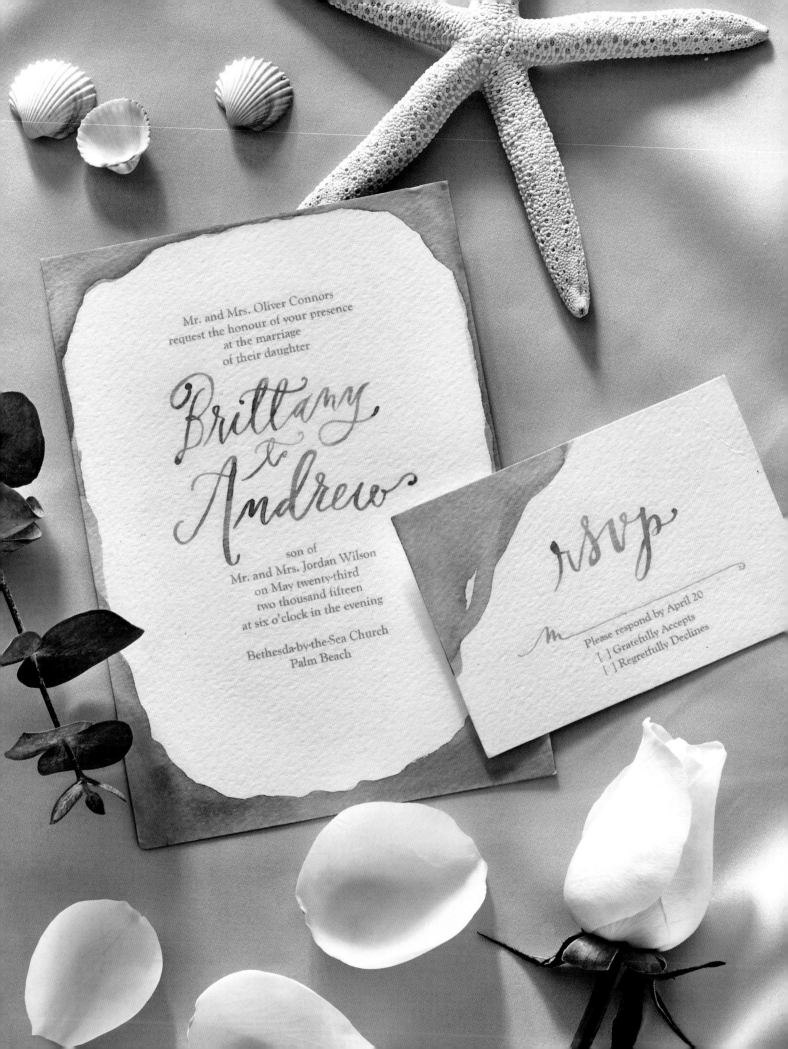

Mr. and Mrs. Oliver Connors
request the honour of your presence
at the marriage
of their daughter

Brittany
&
Andrew

son of
Mr. and Mrs. Jordan Wilson
on May twenty-third
two thousand fifteen
at six o'clock in the evening

Bethesda-by-the-Sea Church
Palm Beach

rsvp

M
Please respond by April 20
[] Gratefully Accepts
[] Regretfully Declines

WATERCOLOR
WEDDING SUITE

A wedding is such a momentous event in the lives of a bride and groom, and it's a wonderful feeling to work with them to help create a specific look or theme for their special day. Combining brush lettering and calligraphy with a printed design is an easy way to add a personal touch to a two-piece wedding suite. This breezy design would be perfect for a beach-themed or other casual wedding.

SUPPLIES

COPY PAPER

PENCIL AND ERASER

RULER

PAPER TRIMMER

140-LB. COLD-PRESS WATERCOLOR PAPER

WORD-PROCESSING OR GRAPHIC-DESIGN PROGRAM

INKJET PRINTER

WATERCOLORS OF YOUR CHOICE: *WINSOR & NEWTON IN PRUSSIAN BLUE AND HOOKER'S GREEN*

WATER BRUSH: *PENTEL ARTS AQUASH WATER BRUSH, FINE TIP*

LARGE ROUND WATERCOLOR BRUSH: *HARMONY SQUIRREL QUILL, SIZE 10*

PALETTE

CALLIGRAPHY NIB AND HOLDER (OPTIONAL)

JAR OF WATER

LIGHTPAD (OPTIONAL)

Design the Layout

1 With pencil, draw two 5" x 7" (12.5 x 18 cm) rectangles on several sheets of copy paper. Play around with ideas, drawing rectangles to represent blocks of text that will be printed and experimenting with different types of lettering. Do the same for the response card in 4" x 6" (10 x 15 cm) boxes.

Cut Paper into Cards

2 Using a paper trimmer, measure and cut the watercolor paper into two card sizes: 5" x 7" for one wedding invitation and 4" x 6" (10 x 15 cm) for two 2" x 3" (5 x 7.5 cm) RSVP cards.

Type and Print Out Cards

3 With a word-processing or graphic-design program, type the details of the wedding invitation and RSVP card using the layout designed in Step 1 as a guide. Place the blocks of texts in a way that is appealing to your eye, leaving space for the brush lettering. Create two response cards on one 4" x 6" sheet. Lay out the first half of the card, then copy and paste it to the second half of the card.

4 Print the typed layout onto the precut cards. Most inkjet printers are designed to print photos in 5" x 7" and 4" x 6" formats. I use this feature on my printer to print out the cards. Once the cards are printed, cut the 4" x 6" response cards in half.

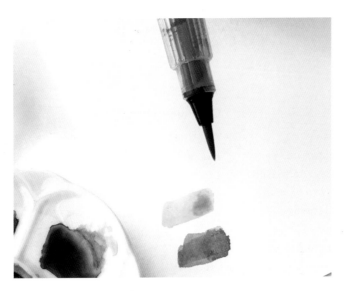
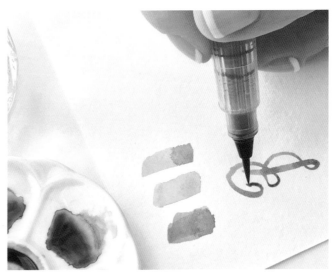

Practice the Lettering

5 Select the watercolors for your project and wet them with a few drops of warm water. If you're working with more than one color, mix them on a palette with a brush. Create swatches of colors until you find the right mix of colors. (See Color Swatching on page 49.)

6 Using scrap pieces of watercolor paper, practice brush lettering the bride's and groom's names and "RSVP." Repeat until you feel comfortable with the lettering.

Letter the Cards

7 To help with the placement of the lettering, create a guide in pencil. You can do this in two ways: (1) Lightly pencil the design onto the card. Once the watercolor dries completely, erase the pencil lines. (2) Draw the names on a sheet of copy paper, place it under the card, and lay both on a lightpad. Repeat this step for the response card. Add the brush lettering with the water brush and watercolor.

VARIATIONS

♥ **Create coordinating place-setting cards or thank-you notes.**

♥ **Use the same technique for shower invitations.**

♥ **For a modern look, place just a dash of watercolor across the invitation.**

♥ **Try lettering with drawing gum to use as a resist under watercolor. (See Watercolor Place Cards on page 86 for steps.)**

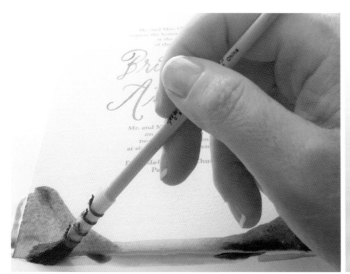

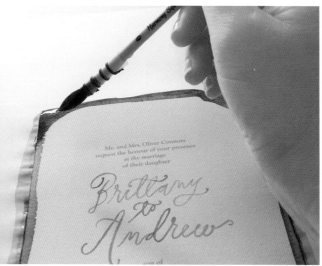

Add a Border

8 Place a sheet of copy paper under your card to protect the surface and absorb the excess water. Using a round watercolor brush, begin applying a watercolor wash onto the edges and corners of the wedding invitation. To achieve a layered look, allow the wash to naturally puddle in places. Allow the paint to dry. Repeat this process at the top left corner of the response card.

TIP ❯ **Don't use newspaper under your stationery to absorb the excess water. The ink in the newpaper may bleed through to your invitation.**

GOLD FOIL
VALENTINES

You'll amaze your friends with these Valentine's Day cards that feature your lettering in sumptuous gold foil. And they'll never guess how easy it is. You simply print your card with an inkjet printer and run it through a laminator to adhere the gold foil. The focus of the design I chose is the ideal Valentine's Day word—*love*—on a vibrant hot-pink watercolor background. Coordinate the cards with crisp white envelopes.

SUPPLIES

COPY PAPER

PENCIL, ERASER, AND RULER

CALLIGRAPHY INK IN BLACK: *WINSOR & NEWTON*

WATER BRUSH: *PENTEL ARTS AQUASH WATER BRUSH, FINE TIP*

9" X 12" (23 X 30.5 CM) TRANSLUCENT MARKER PAPER: *CANSON PRO LAYOUT MARKER*

SCANNER AND COMPUTER

ADOBE PHOTOSHOP OR ILLUSTRATOR

LASER PRINTER

LIGHTPAD (OPTIONAL)

WATERCOLORS: *DR. PH. MARTIN'S HYDRUS WATERCOLOR IN QUINACRIDONE MAGENTA*

WATERCOLOR BRUSH: *SILVER BLACK VELVET ROUND BRUSH, SIZE 14*

PALETTE

140-LB. HOT-PRESS WATERCOLOR PAPER, TRIMMED TO 8½" X 11" (21.5 X 28 CM)

JAR OF WATER

PAPER TRIMMER

9" (23 CM) LAMINATOR: *ROYAL SOVEREIGN*

THERM O WEB DECO FOIL IN GOLD

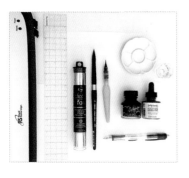

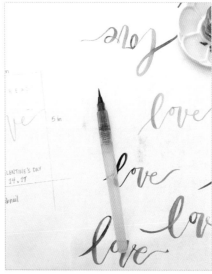

Design the Layout and Lettering

1 With copy paper and a pencil, draw several 3½" x 5" (9 x 12.5 cm) rectangles to sketch designs for the card.

TIP ❯ **The 3½" x 5" (9 x 12.5 cm) card fits within a 4 bar size envelope.**

2 Next, with a water brush and slightly diluted black calligraphy ink, brush letter the word *love* on marker paper. Scan the design and digitize it using Photoshop or Illustrator. (See page 125 for instructions.)

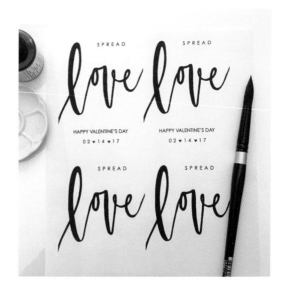

Create the Design Layout

3 With Adobe Photoshop or another graphic-design program, create a new file with an 8½" x 11" (21.5 x 28 cm) layout. Use guidelines to measure four 3½" x 5" (9 x 12.5 cm) cards. Use the Place command to bring in the digitized word. Design the first card based on the sketch, then copy the group of layers three times, placing the cards evenly on the page.

4 If you'd like to check the placement of the watercolor swatches you will be painting with a lightpad, print the page onto copy paper.

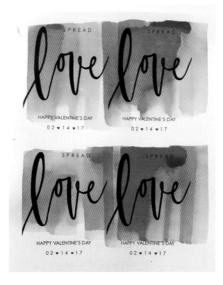
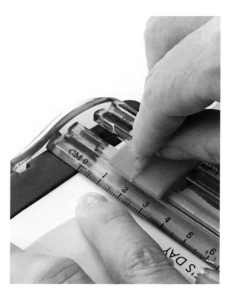

Create the Watercolor Wash

5 Wet the watercolors with a few drops of warm water. Using a lightpad, place the printed copy of the design underneath the sheet of watercolor paper. If you do not have a lightpad, estimate where you want to place the paint. Apply the watercolor onto the watercolor paper in four squares on which your design will be printed. Let the paint dry completely.

Print the Card Layout

6 Print the card design onto the dried watercolor paper using a laser printer. It's important to use a laser printer to print the design onto the watercolor paper. The toner adheres the gold foil to the paper when heated by the laminator.

7 With a paper trimmer, cut the watercolor paper in half horizontally. You now have two pieces of paper with two card designs on each piece.

Laminate the Foil

8 Turn on the laminator and allow it to heat up. Take a sheet of foil and trim it to match the size of one piece of the watercolor paper (8½" x 5½" [21.5 x 14 cm]).

9 Fold a sheet of copy paper in half horizontally. Nest the watercolor paper, toner side up, into the copy paper. Then lay the foil on top of the watercolor paper, gold foil side up.

10 Place the folded edge of the copy paper into the laminator. Allow the paper to roll through the laminator. The paper will come out the other side.

11 Open up the folded paper and gently remove the gold foil from the watercolor. Ta-da! It's like magic!

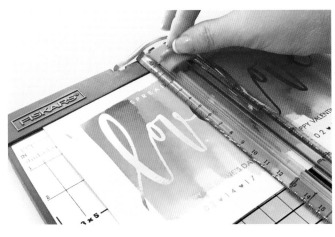

VARIATIONS

❦ Gold foil is so much fun to work with. Try this technique with Christmas cards, wedding invitations, save-the-date cards, and even quotes to be framed.

❦ If you like the look of gold lettering but aren't ready to try laminating, you can try gold gouache, Finetec Artist Mica Watercolors, or gold ink.

12 With a paper trimmer, cut the watercolor paper into 3½" x 5" (9 x 12.5 cm) cards.

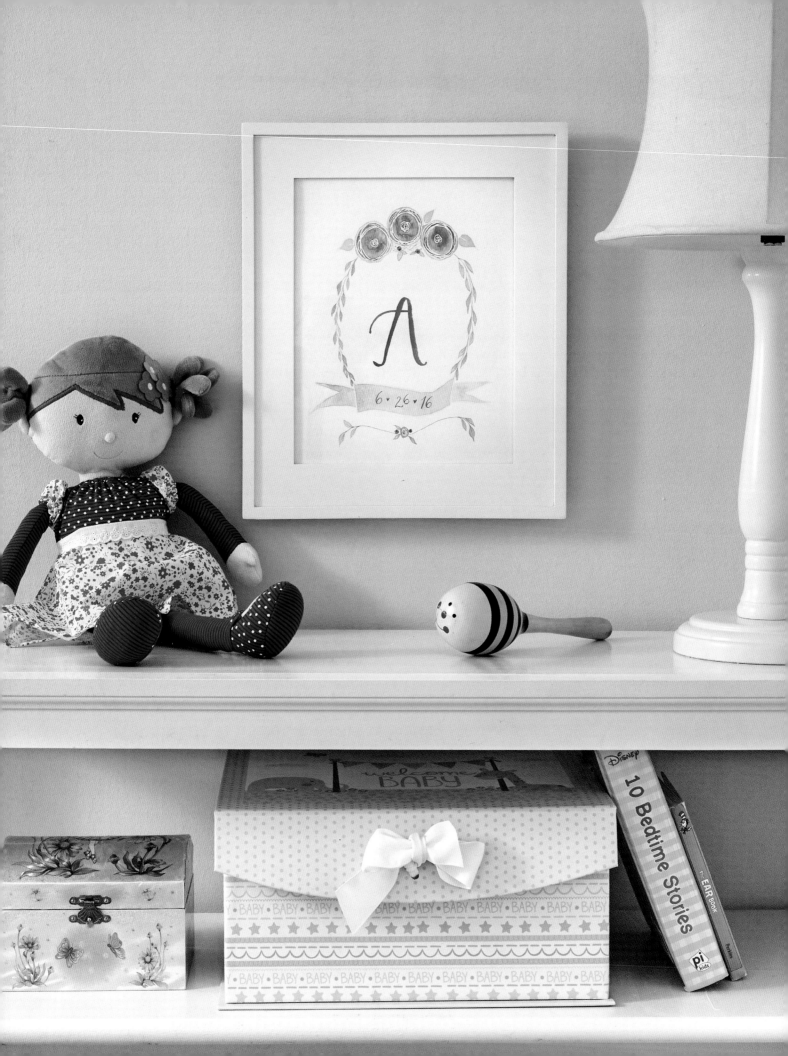

WATERCOLOR
NURSERY ART

This sweet little watercolor project is perfect for a child's room or as a gift for a new baby. By modifying the color scheme and embellishments, this simple concept could be used for a wide variety of ideas, including a wedding anniversary gift or to commemorate any other special day or event. Outlining the flowers and banner with drawing gum before painting them with watercolors allows you to create beautiful details with crisp white lines and spaces.

SUPPLIES

140-LB. COLD-PRESS
WATERCOLOR PAPER

HB OR 2B PENCIL

DRAWING GUM: *PÉBÉO*

QUILL NIB AND HOLDER: *HUNT
CROW VINTAGE QUILL HOLDER
AND HUNT 102 NIB*

DAPPEN DISH

JAR OF WATER

WATERCOLORS: *PRIMA
MARKETING WATERCOLOR
CONFECTIONS PASTEL DREAMS
SET IN CRIMSON, ROSE, AND
LEMONADE; DANIEL SMITH
EXTRA FINE WATERCOLOR IN
FUCHSITE GENUINE; WINSOR &
NEWTON IN SAGE GREEN*

WATERCOLOR BRUSHES: *SILVER
BLACK VELVET ROUND BRUSH,
SIZE 14; PRINCETON MINI
DETAILER, SIZE 3/0*

PALETTE

WATER BRUSH: *PENTEL ARTS
AQUASH WATER BRUSHES, FINE
AND LARGE TIPS*

GUM ARABIC

PAPER TRIMMER

KNEADED ERASER

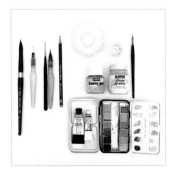

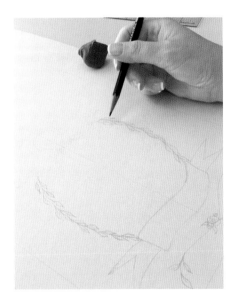

Design the Layout

1 Lightly sketch out your design with pencil on cold-press watercolor paper. For my example, I created an oval design embellished with simple circular flowers at the top and leaves on the sides and a swallowtail banner at the bottom.

. .

TIP ❯ **Draw very lightly to minimize the lines that will show through the paint and enable you to erase the lines when the painting is complete.**

. .

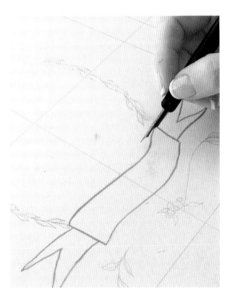

Outline with Drawing Gum

2 For convenience, fill a dappen dish with drawing gum. Then, using a quill nib dipped in drawing gum, draw over the lines that create the banner.

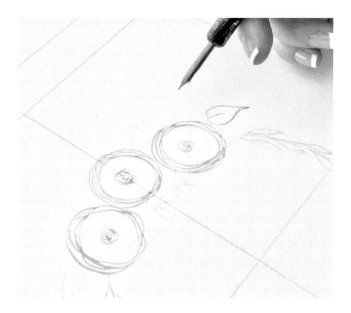

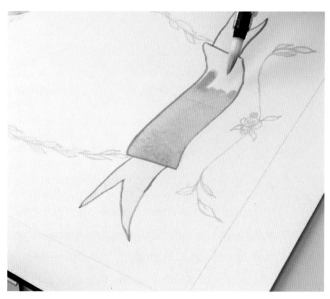

3 Next, draw intertwined circles around the edge and swirly circles in the middle of each flower. Outline the leaves next to the top three flowers. Allow the drawing gum to dry completely.

Paint the Banner and Flowers

4 Wet the paints with a few drops of warm water. Paint the banner using a large round watercolor brush or water brush, filling in the areas outlined by the drawing gum with crimson rose watercolor.

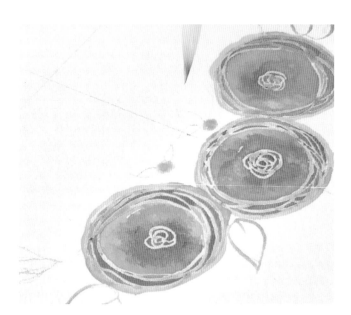

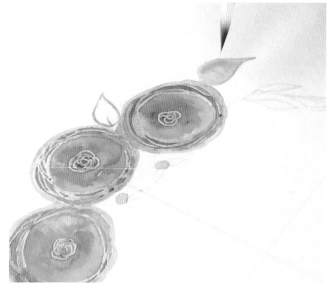

5 Paint the flowers using two watercolors. I used a deep rose and a light pink. Paint the inner circles and outer edges with the deep rose color. Then paint the section between the edge and inner circle with a light pink color, allowing the two colors to blend at the points where they meet. Use light washes to get a gradient effect.

6 Paint a thin line of color around the outer edge of each flower and paint small dots of colors for the rosebuds. Next, fill in the large leaves outlined in drawing gum with sage green watercolor. Let the paint dry.

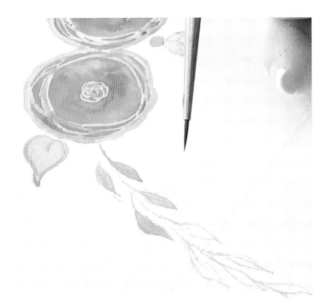

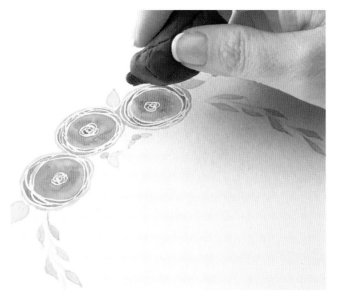

Paint the Wreath of Leaves

7 With a small watercolor brush, paint the tiny leaves of the wreath. Use two slightly different shades of green to create variety. With the same small brush, paint the leaves on the embellishment below the banner and the small rosebuds in a pink or rose color. Allow the paint to dry.

Add Details

8 Once all sections of the painting have dried, gently remove the drawing gum, with the kneaded eraser. Take care not to tear the surface of the paper.

TIP ❯ The painting must be completely dry before you remove the drawing gum. If the paper has any moisture, the eraser will most likely tear the surface of the paper.

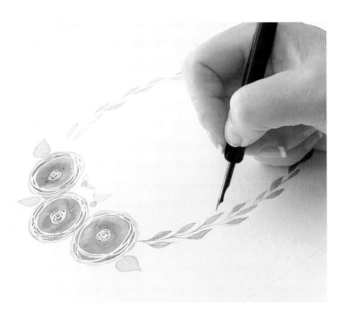

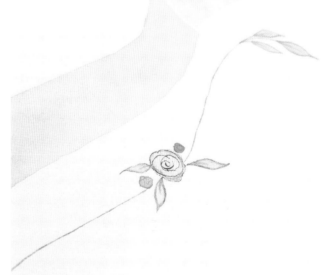

9 Next, take a slightly darker shade of green and mix with water. Add a small amount of gum arabic, which helps create a more distinct line. Trace over the stems and outer leaf edges using a quill nib and the watercolor mixture. Create any small details on the stems and leaves including the embellishment below the banner.

10 To create details in the small rose buds, repeat Step 9, using a rose color.

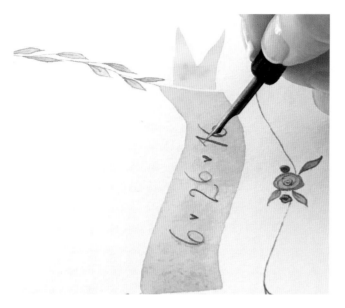

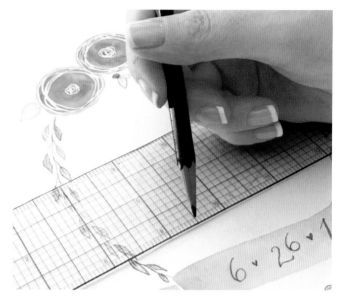

Script the Birth Date

11 To help with the spacing of the birth date within the banner, draw a light line down the center in pencil. Lightly draw the birth date, beginning with the center number and drawing the numbers to the left and right. Use the pencil layout as a guide and script in the date with the rose watercolor mixture and nib.

. .

TIP ⟩ **You could also use a water brush to brush letter the birth date.**

. .

Paint the Letter

12 Create a guide in pencil by lightly penciling a baseline and ascender line and a vertical line through the middle of the design to center the letter.

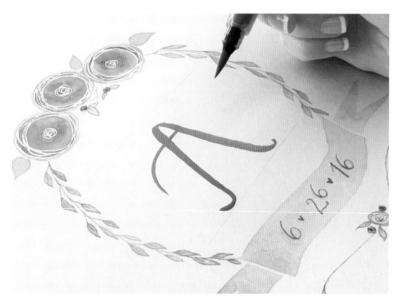

13 With a water brush, paint in your letter. Erase any remaining pencil lines, trim the paper to size, and frame.

VARIATIONS

❦ **Are you a quilter? Scan your design, print or transfer it onto fabric, and incorporate it into a quilt for a new baby for an instant heirloom.**

❦ **This design would make a beautiful cover for a photo album or baby book.**

❦ **Letter a colorful alphabet sampler to help a child learn the ABCs.**

LOVELY LETTER SAMPLER

Here is a letter exemplar you can use to customize your watercolor art. The alphabet shown on page 63 can also be used as inspiration, or challenge yourself to come up with your own style.

$$A \quad B \quad C \quad D \quad E \quad F \quad G$$

$$H \quad I \quad J \quad K \quad L \quad M$$

$$N \quad O \quad P \quad Q \quad R \quad S$$

$$T \quad U \quad V \quad W \quad X \quad Y \quad Z$$

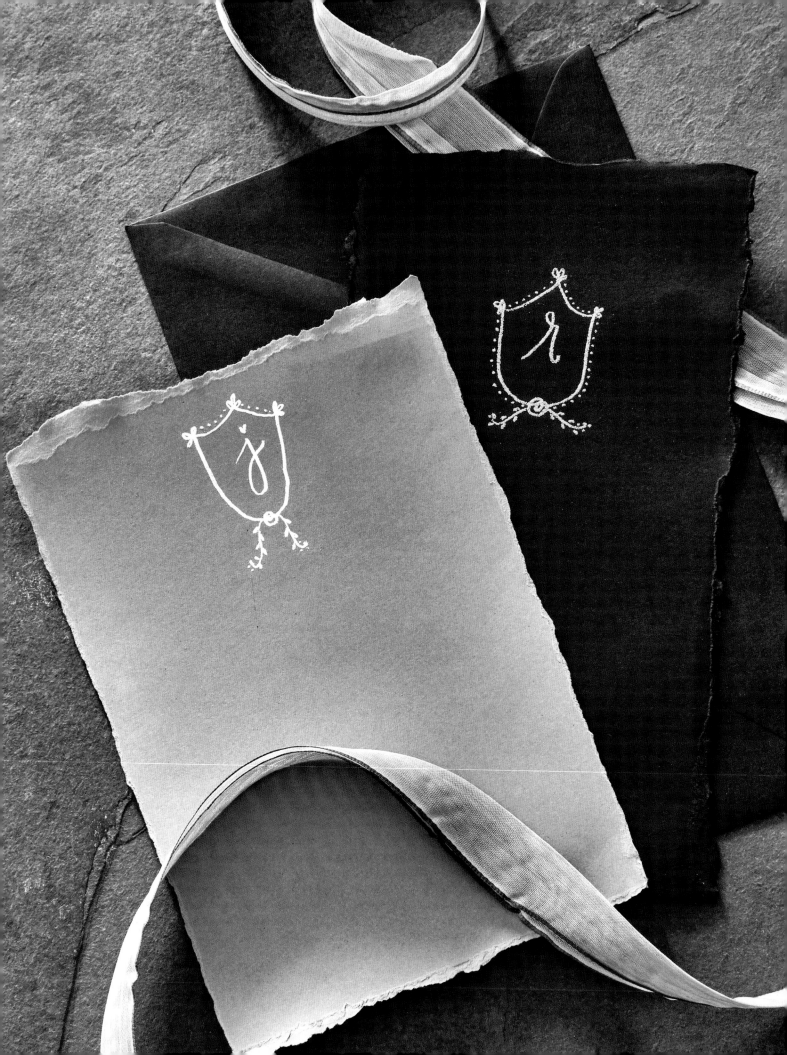

EMBOSSED MONOGRAM
STATIONERY

Create elegant, bespoke monogram stationery for yourself or a friend using basic card stock and an embossing pen and powder. The pen contains slow-drying ink that acts as a binder to embossing powder sprinkled onto the ink. A heat gun is used to melt the powder and form a raised, dimensional design. Pair the clear embossing ink with the powder color of your choice. Deckling the edges of the paper gives it the look of handmade paper.

SUPPLIES

8½" X 11" (21.5 X 28 CM) 65-LB. CARD STOCK: *RECOLLECTIONS NEUTRAL PACK* IN MEDIUM GRAY

RULER

PENCIL AND ERASER

LARGE ROUND PAINTBRUSH

JAR OF WATER

COPY PAPER

BRUSH-TIP EMBOSSING PEN WITH CLEAR INK: *ZIG EMBOSS SCROLL & BRUSH*

EMBOSSING POWDER: *RECOLLECTIONS DETAIL EMBOSSING POWDER* IN SNOW

SMALL PAINTBRUSH

HEAT GUN

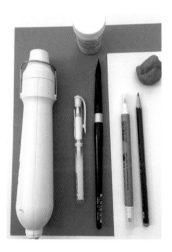

Deckle the Edges

1 Fold the piece of card stock in half widthwise.

2 On each of the narrow ends of the folded paper, measure ¾" (2 cm) from the edge and draw a horizontal line with a ruler.

3 On the open end of the folded paper, measure ½" (1.3 cm) from the edge and draw a horizontal line with a ruler. Repeat on the other side.

4 Unfold the paper, place the ruler on one of the marked lines, and, with a wet paintbrush, apply water along the line.

THE EMBOSSING SETUP

To emboss your design, you will need to use an embossing pen and embossing powder. The pen contains slow-drying ink and acts as a binder to the embossing powder when the powder is sprinkled onto the ink. There are a few different brands and styles of embossing pens on the market today. My preference is to use an embossing pen with a brush marker tip because it is more versatile in creating thick and thin lines as well as small details. The heat applied

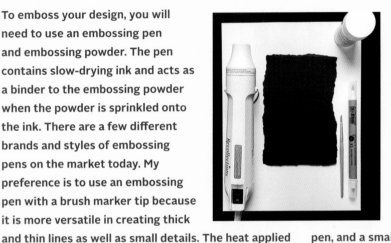

with the heat gun melts the powder, creating a raised, dimensional design.

Prepare your space with the supplies you will need to emboss the design. Place a spare piece of copy paper under the piece you're embossing to catch the excess embossing powder. Plug your heat gun into an electrical socket and place it near you so that you can easily maneuver it when ready. Place the jar of embossing powder, the embossing pen, and a small paintbrush nearby for ready use.

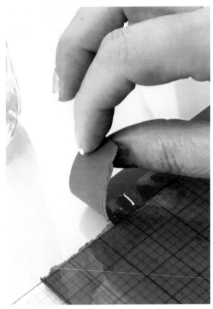

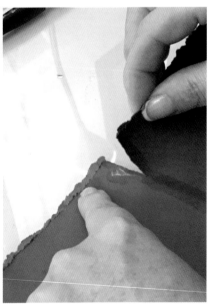

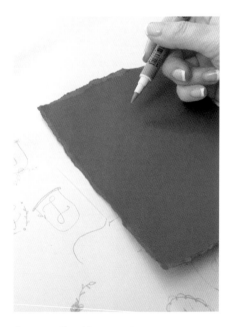

Create the Monogram

5 Once the water has absorbed into the paper, tear the paper loosely along the edge of the ruler. To make an interesting edge, do not follow the ruler too closely. Repeat Steps 4 and 5 with the other three marked lines.

6 Wet the center fold with the wet paintbrush. Once the water has absorbed into the paper, tear along the paper fold. You now have two 5" x 7" (12.5 x 18 cm) pieces of paper.

7 On a piece of copy paper, sketch out the design of your monogram. (See page 100 for a few ideas.) Prepare your space with the supplies you will need to emboss the design. See The Embossing Setup, above. Draw the monogram design on the stationery paper with the embossing pen.

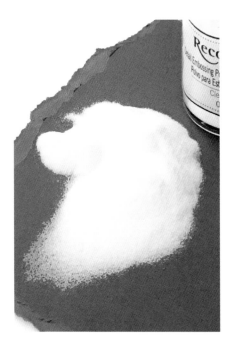

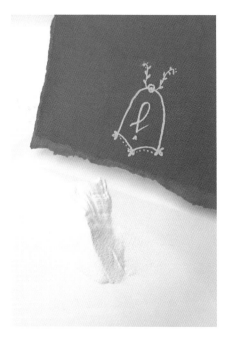

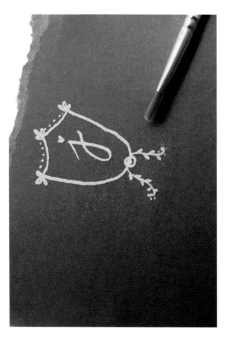

8 Once you have completed the design, cover it completely with embossing powder. Be sure to cover any wet ink with embossing powder.

9 Allow the embossing powder to set for 2 or 3 minutes, then pick up the stationery paper and pour off the excess powder onto the copy paper.

10 With a small, dry paintbrush clean away any small particles around the design. Pour the excess embossing powder back into its container.

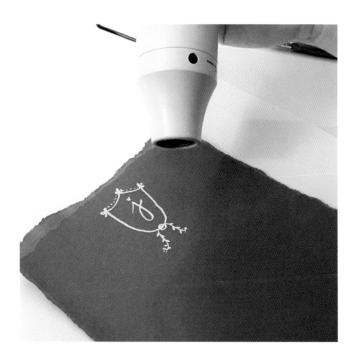

11 Turn on the heat gun and allow it to warm up for about 30 seconds. Apply the heat to the design, allowing the heat to melt the embossing powder. Do not hold the heat gun in any one place too long because the paper will begin to warp. The embossing is complete once the entire design has melted.

VARIATIONS

❦ **Card stock and embossing powders come in myriad colors, so the color combinations for this project are limitless.**

❦ **For dark card-stock designs, it's fun to write a note in the body of the stationery with an opaque white or metallic ink dip pen.**

❦ **Instead of just a monogram, letter a full name.**

EMBOSSED
BOOK COVER

Embossing with ultra-thick embossing powder offers a creative way to decorate or personalize any journal cover, sketchbook, or photo album. This type of embossing powder is made up of larger particles than the traditional embossing powders, and you can further build up the embossed designs by applying multiple layers. The embossing powder is clear, and I chose to use a clear embossing ink so that it looks like the lettering is part of the cover.

SUPPLIES

COPY PAPER

PENCIL AND ERASER

JOURNAL

BRUSH-TIP EMBOSSING PEN WITH CLEAR INK: *ZIG EMBOSS SCROLL & BRUSH*

RANGER ULTRA THICK EMBOSSING POWDER IN CLEAR

SMALL PAINTBRUSH

HEAT GUN

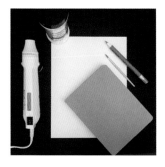

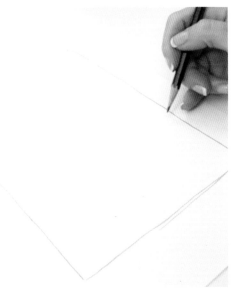

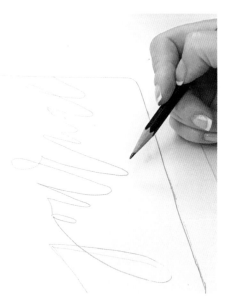

Develop the Cover Design

1 On a piece of copy paper, trace around the edges of the journal with a pencil. This will help you create a design that perfectly fits the cover.

2 Begin designing the cover of the journal within the traced edges.

TIP ⟩ **Don't try to sketch your design in pencil on your journal. It will show through the embossing and not be erasable.**

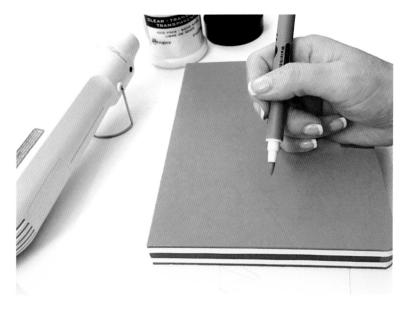

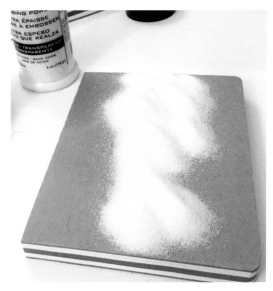

Create an Embossed Design

3 Once you're happy with your design and your supplies are in place (see The Embossing Setup on page 82), begin drawing your design onto the journal cover using the embossing pen.

4 Once you have completed the design, cover it completely with the embossing powder. Make sure any wet ink is covered.

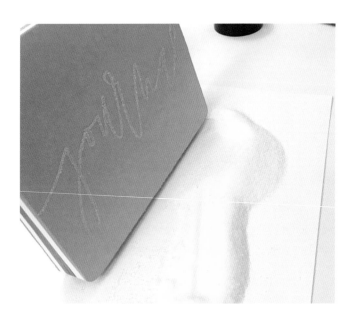

5 Allow the embossing powder to set for a couple minutes, then pour the excess powder onto the copy paper. With a small, dry paintbrush, clean away any stray powder particles.

6 Gently fold the copy paper to create a funnel.

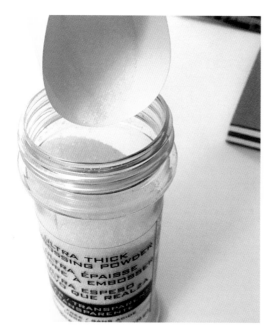

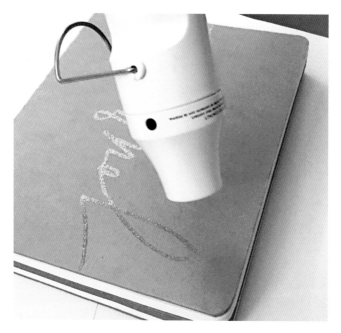

7 Pour the excess powder back into the jar.

8 Turn on the heat gun and allow it to warm up for 30 seconds. Apply heat to the design, allowing it to melt the embossing powder. Do not hold the heat gun in any one place too long because the cover may begin to warp.

. .

TIP ❯ **If the melted layer cools too quickly, carefully retrace your design with the embossing pen to adhere another layer of embossing powder.**

. .

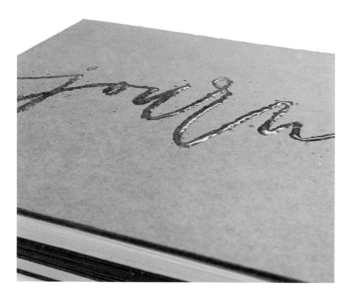

VARIATIONS

❦ **Emboss the cover of a photo album with the names of a just-married couple or a new baby.**

❦ **Use the same technique to create embossed greeting cards.**

9 To increase the depth of the design, repeat Steps 3–8. You can continue this process until you reach the dimension you desire. The journal cover I created consists of three layers of embossing.

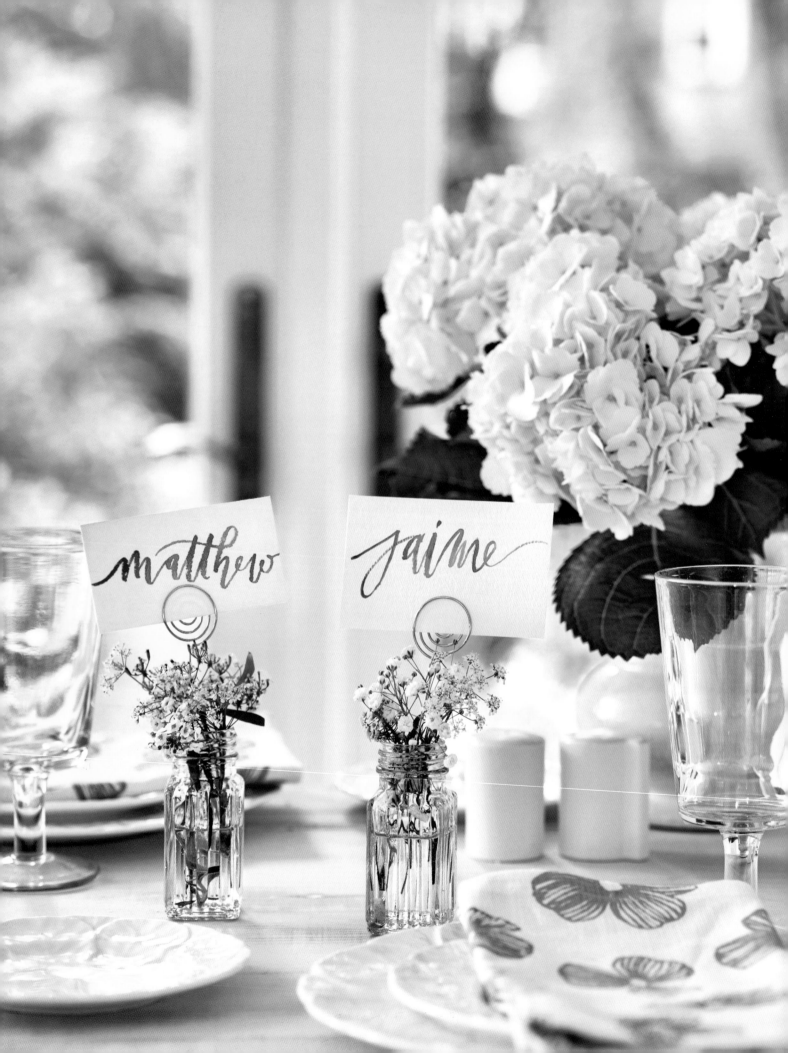

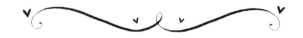

WATERCOLOR
PLACE CARDS

These watercolor place-setting cards will add a personal touch to your dinner party, shower, or other gathering. I've created two versions: For the more feminine version, I scribed the names with drawing gum to use as a resist under watercolor, and in the other, more masculine design, I brush lettered the names directly on the cards. They're so simple and attractive, your guests will want to take them home as a memento of the event.

SUPPLIES

140-LB. COLD-PRESS WATERCOLOR PAPER

PAPER TRIMMER OR SCISSORS, PENCIL, AND RULER

WATERCOLOR PAINT: *WINSOR & NEWTON IN SAP GREEN*

PALETTE

ROUND WATERCOLOR BRUSH: *SILVER BLACK VELVET, SIZE 14*

WATER BRUSH FOR LETTERING: *PENTEL ARTS AQUASH WATER BRUSH*

JAR OF WATER

CALLIGRAPHY NIB AND HOLDER: *KOH-I-NOOR 127 N CORK-TIPPED PEN HOLDER AND ESTERBROOK FREE HAND 1000 NIB*

DRAWING GUM

DAPPEN DISH

KNEADED ERASER

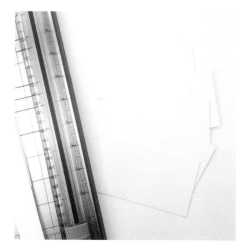

VERSION 1 **Cut the Paper**

1 Using a paper trimmer, cut the watercolor paper into 4" x 2½" (10 x 6.5 cm) rectangles using the paper trimmer. If you don't have a paper trimmer, use a ruler and pencil to lightly draw a grid of rectangles. Cut along the lines with scissors. Erase any pencil markings on the cards.

Brush Letter Names

2 Wet the watercolor paint with a few drops of warm water. Using a water brush, brush letter the guests' names onto the cards. Begin the stroke on the left-hand edge of the card. Script the name and then extend the stroke of the last letter to the full length of the card. Let dry.

TIP > **Use the leftover scraps of watercolor paper from Step 1 to warm up and practice writing their names.**

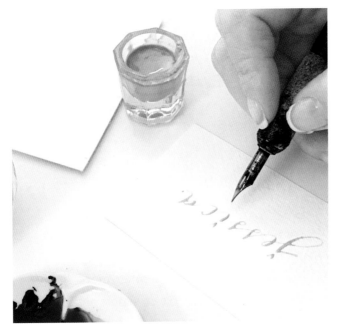

VERSION 2 Scribe the Names & Embellishments

1 Follow Step 1 on page 89 to cut paper into cards. Pour some drawing gum into a dappen dish. Dip the nib of the calligraphy pen into the drawing gum as you would with ink. Write the guests' names in your own personal style.

2 Add an embellishment if you like. I decided to add a leaf embellishment. Set the cards aside to dry.

TIP ⟩ **If you make a mistake or the drawing gum globs, allow the gum to dry. Then erase the gum with a kneaded eraser. The card should be salvaged and you can start again.**

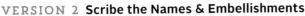

3 Brush the watercolor paint over the name and embellishment on the card. Keep in mind that when the drawing gum is removed, the underlying paper will be revealed. Make sure that all letters and embellishments have paint around the edges to ensure your markings will be revealed. Let the watercolor naturally puddle in areas. Create an appealing shape for the left edge of the wash.

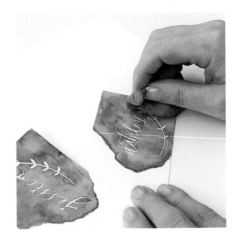

4 Once the place cards have dried completely, erase the drawing gum with the eraser. Take your time and be gentle so you do not tear the paper.

TIP ⟩ **If the nib of the pen becomes clumpy from the drawing gum, scrub the nib with a toothbrush and soap and water.**

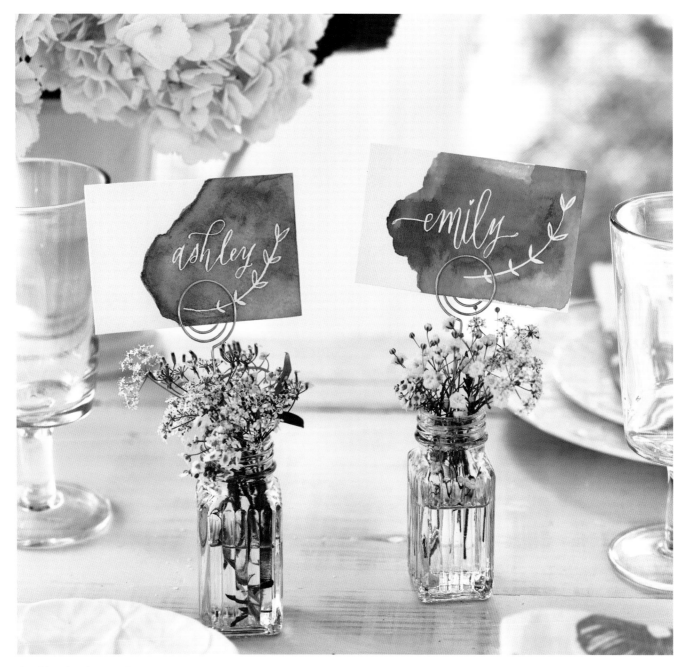

Combine the place cards with small vases of fresh flowers to complement a gorgeous table setting.

MORE VARIATIONS

❥ Punch out card stock in different shapes with lever-style paper punches to create place-setting cards and gift tags.

❥ After the event, create matching thank-you cards using the same techniques.

❥ There are many ways to display your place cards, such as in mini picture frames (choose your paper size to fit the frames). You can also make a taller card and fold it in half so it will stand on its own.

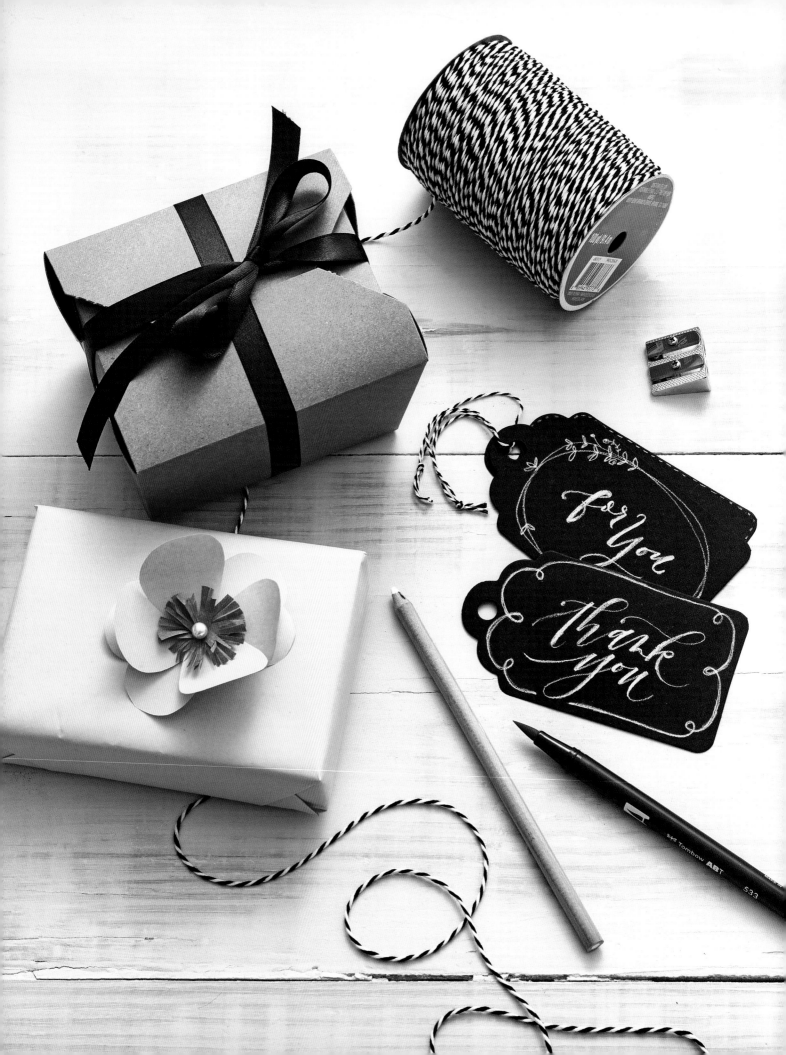

Drawing Letters

THE TERM *HAND LETTERING* is often distinguished from calligraphy and brush lettering as the "art of drawing letters." The key word here is "drawing." With calligraphy and brush lettering, the letters are formed using a series of strokes, which is more like writing. With hand lettering, the letters are drawn in shapes. It encompasses a broad range of styles and is an art form in itself. In this chapter, I share some tips for getting started, including additional supplies that can be used. I'll also demonstrate "faux calligraphy"—a simple and versatile technique that mimics the look of calligraphy.

FAVORITE SUPPLIES

Anyone just starting out drawing letters can begin with a pencil and paper. Of course, you can use a variety of mediums such as pens, markers, and paints, as well as different types of paper. Many of the supplies listed in the calligraphy and brush lettering chapters of this book can also be used in hand lettering. Here are a few of my go-to supplies.

PENCILS

2B Pencil

A soft 2B lead, whether it's in a mechanical or traditional pencil, is my preference. I like the soft 2B graphite to draft designs. If you do not write with too much pressure, the graphite cleans up well with a kneaded eraser.

Prismacolor Ebony Graphite Pencil

For graphic designs, this rich, velvety smooth graphite pencil creates great contrast.

White Charcoal Pencil

A white charcoal pencil is a fun tool to use when lettering on darker papers.

PENS

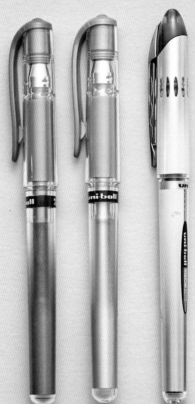

Uni-Ball Signo Pens

These markers write smoothly and come in a variety of colors and tip sizes, and I love how opaque the white ink is. Both the white ink and the metallic inks pop on dark paper. My favorite Signo pens are the UM-100 with a 0.8 mm tip in black, silver, and gold; the Broad UM-153 with a 1.0 mm tip in black, white, and gold; and the white Angelic UM-120 AC gel pens with 0.7 mm tips.

Sakura Pigma Micron Pens

These pens come in a variety of colors and nib sizes as well as a brush nib, which is useful for filling in large spaces. The finest nibs are ideal for intricate details. I use the black ink pens on translucent marker paper to digitize my designs. It provides a great contrast for a clean scan.

MARKERS

Tombow Dual-Brush Markers

These versatile markers are great for brush lettering, but they're also wonderful for hand lettering. They are fun to draw with and are useful for filling in open spaces.

Paint Markers

Paint markers such as Sharpie Oil-Based Paint Marker and Montana Acrylic Marker enable you to draw on many surfaces other than paper, such as painted wood and even rocks.

ELEMENTS OF LETTERING

There is an infinite number of ways to create letterforms. Here are some common elements you can customize and ideas for creative additions.

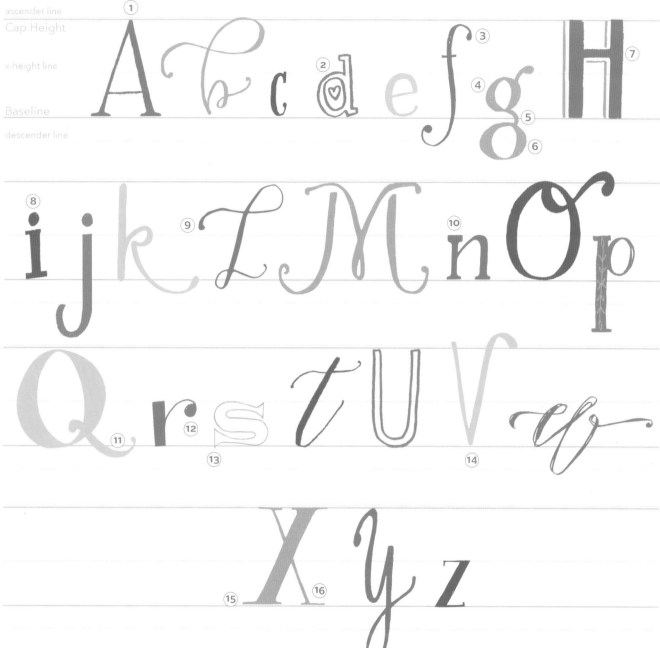

ascender line
Cap Height
x-height line
Baseline
descender line

1 The pointed top of a capital *A* is the apex.

2 Add an embellishment in the *counter* (space within a character).

3 A *terminal* of a stroke doesn't have a serif.

4 A curved stroke that creates a counter is a *bowl*.

5 The *link* connects the bowl to the *loop*.

6 Loop

7 A *cross bar* can be straight or curvy.

8 Try a flower or heart for the *tittle* (dot over *i* and *j*).

9 Make the *swash* simple or ornate.

10 Include a *slab serif* (see Types of Serifs on page 96)

11 Add a flourish with a dramatic *tail*.

12 The terminal can be a teardop shape.

13 *Bracket serif*

14 The bottom point of a capital *V* is the *vertex*.

15 *Hairline serif*

16 A *hairline* is a thin stroke.

HAND-LETTERING STYLES

In lettering and typography, there are three basic styles: serif, sans serif, and script (see Faux Calligraphy on the next page). Each one will lend a different feel to your lettering designs.

HOW TO DRAW A SERIF STYLE

Serifs are small strokes at the ends of the vertical and horizontal strokes of the letters. This style of letter is considered more traditional than sans serif. It is thought to be easier to read in print form and is commonly found in the body of text in newspapers, magazines, and books.

DARLING

1. With the drawing instrument of your choice, begin by writing a word in all caps. Be sure to leave plenty of space between the letters.

DARLING

2. Add serifs to the tops and bottoms of the letters and extend the serifs to the left of the stem in the capital D. See Types of Serifs (below) for the different styles you can try..

DARLING

3. Next, fill in the space between stems of the letters and the serifs. To keep a traditional style, be sure to leave thin strokes that are the upstroke parts of the letter.

HOW TO DRAW A SANS SERIF STYLE

Sans means "without" in French, and the literal meaning of *sans serif* is "without" serifs. This style of letter is considered more modern. It is used as headings in the printed form but is often used as the body of text online because it is considered easier to read when displayed on screen.

DARLING

1. With the drawing instrument of your choice, begin by writing a word all in caps. Be sure to leave plenty of space between the letters.

DARLING

2. Next, draw parallel lines for each line structure of the letter. Draw a horizontal line to square off each letter.

DARLING

3. Fill in the space between the two lines.

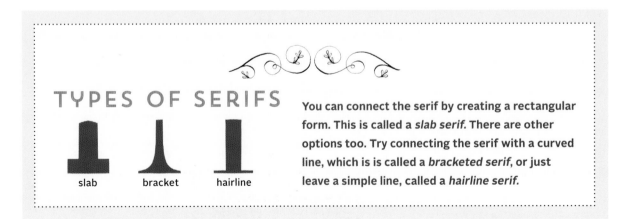

TYPES OF SERIFS

slab bracket hairline

You can connect the serif by creating a rectangular form. This is called a *slab serif*. There are other options too. Try connecting the serif with a curved line, which is is called a *bracketed serif*, or just leave a simple line, called a *hairline serif*.

FAUX CALLIGRAPHY

You can hand draw a script style that looks very much like calligraphy. Faux calligraphy is also useful for larger-scale lettering such as signs that are too large to create with a calligraphy nib.

HOW TO DRAW FAUX CALLIGRAPHY:

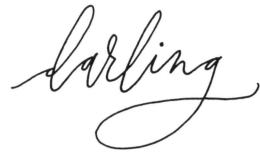

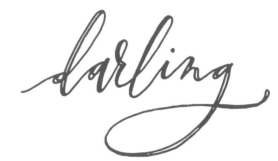

1. With the drawing instrument of your choice, begin by writing a word in cursive. Be sure to leave plenty of space between the letters. I chose the word *darling* for my example.

2. To create a faux calligraphy look, draw a parallel line next to each part of the letter that is a downstroke. It doesn't matter which side of the letter you draw on. The main thing is to leave plenty of space between the letters.

3. Fill in the space between the two lines.

a b c d e f g h i j

k l m n o p q r s t

u v w x y z

In the alphabet above, I left the spaces open to better show the placement of the downstrokes. You can fill them in or leave them open.

DESIGN DOS AND DON'TS

To create beautiful lettering compositions, keep in mind some basic elements of design.

EMPHASIS

When selecting a phrase to design, emphasize key words that add meaning to the phrase. These key words should be the focal point of the design.

SPACING

The right amount of space between words and lines is important to create a cohesive look. If there is too much space, your design will look disconnected and less impactful. Too little space, and your design will be hard to read.

NEGATIVE SPACE

The white, or negative, space in a design is the area where there are no design elements. That blank space is itself a design element. Too much or too little of this negative space and the design will feel off balance.

REPETITION

Repeating elements create a cohesive composition. Select themed elements that are repeated in the design. Repetition is the element that makes things look like they belong. For example, if you use too many different lettering styles, the design will look chaotic.

BALANCE

Balance in a design is achieved when all parts are placed in an aesthetically pleasing arrangement. The weight of your design is evenly distributed by the placement of each element.

refuse to be Average let Your Heart soar as high as it will

— AW TOZER

COMBINING LETTERING STYLES

Now that you've tried out a few types of lettering, you can expand your lettering repertoire by combining styles. Using a couple different lettering styles together is a fun way to add variation to your designs.

HERE ARE SOME GENERAL GUIDELINES:

- Don't mix too many styles or you design will look chaotic. I usually stick to two or three styles.

- Select styles that do not compete with one another.

- Create variation by using different weights, sizes, and spacing between letters.

- Mixing styles is a good way to emphasize a key word or words to add meaning to the phrase. When emphasizing key words, the alternative lettering style(s) should support the emphasized word(s), sort of like a supporting actor. For example, if you use brush lettering for your key words, you could pair it with sans serif lettering to set it off.

- Contrast and complement: Don't use styles that are too similar.

- Create variation by using different weights, sizes, and spacing between letters.

- Don't mix moods. It will lead to a confused message.

- Opposites attract.

FLOURISHES AND EMBELLISHMENTS

Flourishes and embellishments add mood or interest to your designs. They also balance out too much white space. Use them to emphasize a word or words within your message.

Flourishes can be used for entry or exit lines of a letter, word, or phrase. They are the swirly part of the letter that extends beyond the letter itself. You can also create flourishes within the white space of your design.

Embellishments are added elements that create interest. They are usually decorative, such as leaves and flowers. They can also be scrolls and banners or simple lines that help break up the design and communicate a quote.

INSPIRATION IS EVERYWHERE!

In my journey as a lettering artist, I have spent a lot of time studying lettering design and I encourage you to do the same. As you know, letters in themselves can be expressive. We see it all around us each day in print magazines and newspapers, on television and in film, and on the Internet. Simply take a walk around your city or town and you will see a wide variety of letters on street signs, store fronts, and billboards, and even in your local supermarket as part of product packaging. Lettering is everywhere.

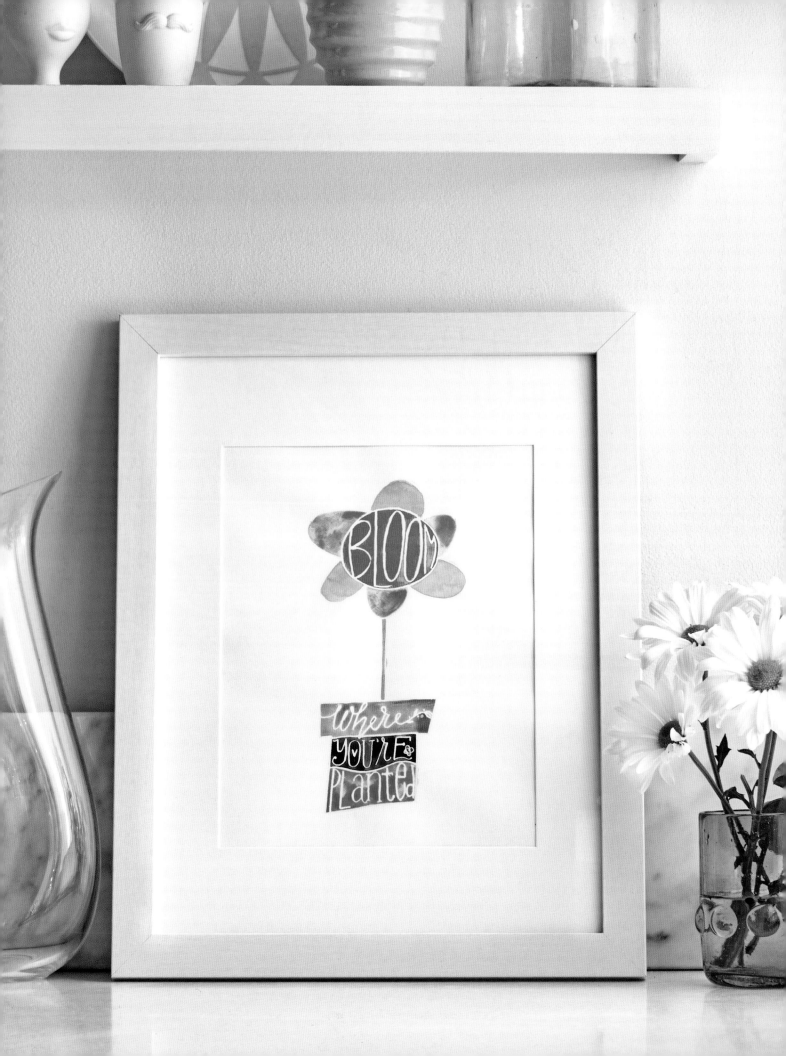

WATERCOLOR
WORD ART

Use your lettering to create original works of art for your home! I like to take favorite quotes and illustrate them graphically by fitting the words inside an appropriate image. One of my favorite quotes is "Bloom where you're planted." I thought it would be fun to illustrate this quote as a potted flower. I drew it with drawing gum, filled in the shapes with colorful watercolors, then erased the gum to reveal a beautiful graphic image.

SUPPLIES

COPY PAPER AND PENCIL

SCANNER, COMPUTER, AND PRINTER (OPTIONAL)

80-LB. DRAWING PAPER: *STRATHMORE 400 SERIES DRAWING PAPER*

LIGHTPAD

QUILL NIB AND PEN HOLDER: *HUNT CROW VINTAGE QUILL HOLDER* AND *HUNT 102 NIB*

DRAWING GUM: *PÉBÉO*

JAR OF WATER

WATERCOLORS: *WINSOR & NEWTON* IN PRUSSIAN BLUE, *PRIMA MARKETING WATERCOLOR CONFECTIONS DECADENT PIES*, AND *DR. PH. MARTIN'S HYDRUS FINE ART WATERCOLOR* IN QUINACRIDONE MAGENTA

PALETTE

WATERCOLOR BRUSH: *SILVER BLACK VELVET* ROUND BRUSH, SIZE 14

KNEADED ERASER

Design the Layout

1 Begin with a phrase you'd like to turn into an image. Doodle a variety of images with the quote in mind and then see how the wording could fit within the design.

2 Redraw your image to the size you want or scan it, enlarge it digitally, and print it out, as I did (see Enlarging Your Drawing on page 104).

ENLARGING YOUR DRAWING

When I'm coming up with a design, I usually don't draw it full size because I don't want to get bogged down with the details of scale. Instead, I digitize the design, resize it to fit the dimensions of the drawing paper, print it out, then quickly trace over the design at the desired size. See page 125 for step-by-step instructions on digitizing your designs.

Transfer the Design to Paper

3 Place the doodle image underneath the drawing paper on top of a lightpad.

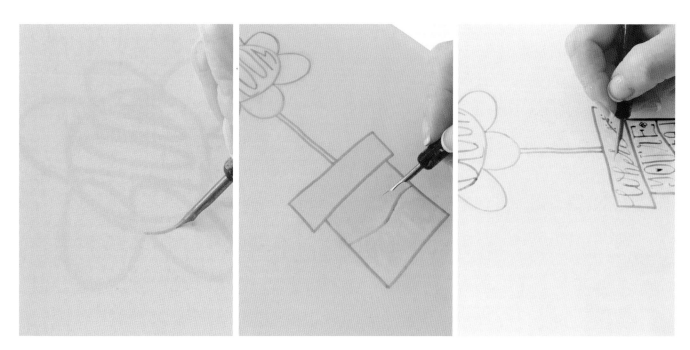

4 Loosely trace the image using a quill nib and drawing gum. The drawing gum will act as a resist, so wherever the drawing gum is placed, paint will not adhere to the paper. Work carefully around the drawing, being careful not to touch the drawing gum. Start at the top of the drawing and work your way down, outlining the structure of the image and then filling in the words. Allow the drawing gum to fully dry before starting the next step.

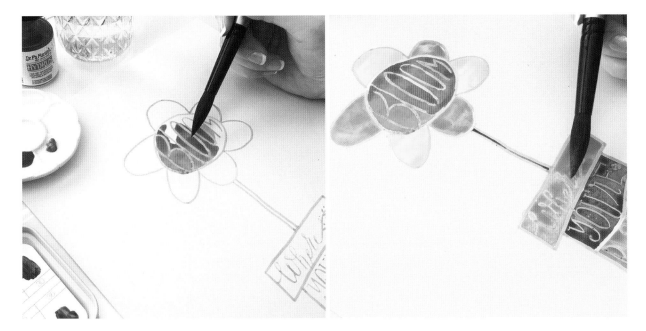

Paint in Watercolor

5 Next, in a variety of watercolors, paint the areas blocked in by the drawing gum. For a variegated watercolor look, allow the watercolor to naturally puddle in areas. Be careful not to use too much water. Allow the watercolor to dry completely before starting the next step.

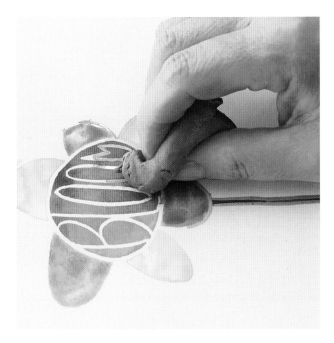

Remove the Drawing Gum

6 Once your painting has completely dried, begin erasing the drawing gum with the kneaded eraser. Take your time and be gentle so you don't tear the paper.

VARIATIONS

- ❦ Other fun graphic images to use in your word art include stars, the sun, and the moon.

- ❦ Fill the image of a baby carriage with quotes about babies or new parents.

- ❦ Flip-flops provide simple outlines for whimsical quotes about beachy things.

- ❦ Looking for phrases to turn into graphic word art? Try websites such as brainyquote.com or goodreads.com or search "Quotes about _____."

WRITTEN
IN STONE

Once you become comfortable with creating your own style of lettering, you will want to letter on all kinds of surfaces. Rocks are a fun object to draw on because they're easy to find, they each have their own unique shape, and their earthiness provides a nice contrast to your lettering. I like to write inspirational messages that are meaningful to friends and family and give them as gifts to use as paperweights or decorations.

SUPPLIES

COPY PAPER

PENCIL AND ERASER

SMOOTH STONES:
MARGO GARDEN PRODUCTS
MEXICAN BEACH PEBBLES
(3"–5"/7.5–12.5 CM)

ACRYLIC WATER-BASED PAINT
MARKER: MONTANA ACRYLIC
MARKER IN WHITE (0.7 MM)

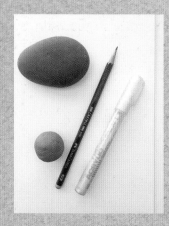

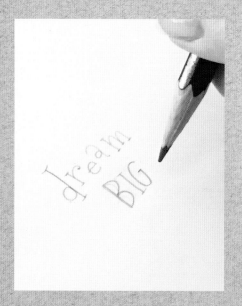

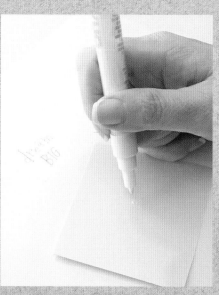

Design the Layout

1 Study the shape of the selected rock. On a piece of copy paper, sketch out designs. My word choice for this project is "dream big." I chose to write the word *dream* in a whimsical fashion. For the word *big*, I played around with the meaning of the word and drew the letters in all caps.

Ink the Design

2 Prepare the paint marker by shaking it, then prime it by pushing the tip of the marker on a scrap piece of paper until the paint begins to flow.

TIP ❯ **It may be helpful to trace around the rock with a pencil to develop the design on a similar shape and size.**

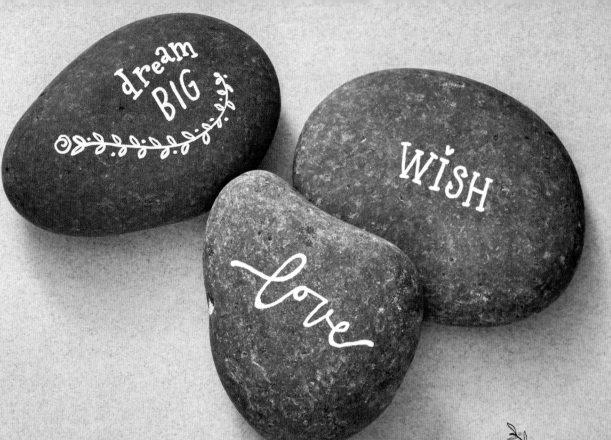

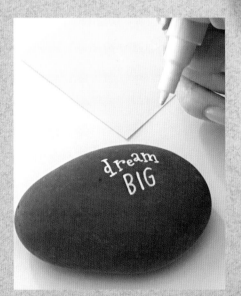

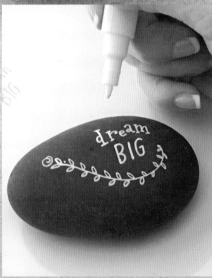

VARIATIONS

❥ Write a greeting on a larger rock and place it near your front door to welcome guests.

❥ Flat pieces of slate are available for purchase, and some come with a cord for hanging. Add lettering to create an eye-catching sign.

❥ Small stones can be glued to magnets or used in kids' craft projects.

❥ Letter guests' names on stones to create unique place settings.

❥ If the stones will be handled frequently, you can seal them with Mod Podge or an acrylic varnish spray. If you're planning to display them outdoors, seal them with a spar urethane sealer.

3 With the paint marker, draw the design on the rock while looking at the sketched design. Take your time. For best results, relax and do not rush the process.

Add an Embellishment

4 If you like, you can add embellishments to the design. I drew a stem mimicking the contour of the rock, then I added leaves to it. I topped the stem with a whimsical rose by drawing a swirly circle.

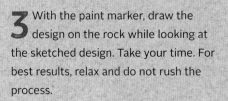

TIP ❯ If you're worried about being able to duplicate your design on the rock, you can first write it with a white mechanical fabric pencil, which can be easily erased.

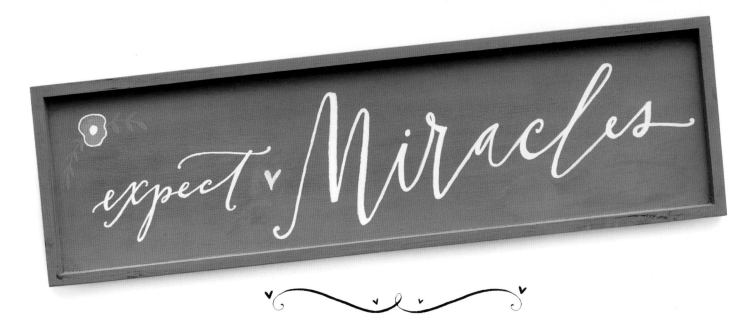

FAUX CALLIGRAPHY
WOODEN SIGN

I love hanging inspirational quotes in my home. They're gentle, uplifting reminders I encounter throughout the day. For this quick-and-easy project, I painted a plain wooden sign with milk paint and used faux lettering and oil-based Sharpies to add the quote. The flat finish of the milk paint lends a vintage look to the piece and provides a smooth base for lettering.

SUPPLIES

RAW WOODEN SIGN, 5⅛" X 18" (13 X 45.5 CM)

SEALER: *FOLK ART MILK PAINT BONDING PRIMER AND SEALER*

PAINTBRUSH: *FOLK ART MILK PAINT BRUSH, 1¼" (3.2 CM)*

PAINT: *FOLKART MILK PAINT* IN CABINET MAKER'S BLUE

PLASTIC CUP

CHALK PENCIL: *FONS & PORTER CHALK PENCIL*

SHARPIE OIL-BASED PAINT MARKERS IN WHITE EXTRA-FINE POINT, WHITE FINE POINT, PINK FINE POINT, AND LIME FINE POINT

SCRAP PIECE OF BLACK CARD STOCK

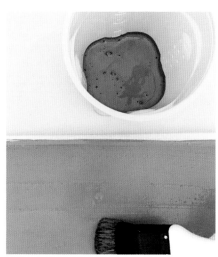

Prepare the Wooden Sign

1 Pour the sealer into a plastic cup. With a brush, coat the sign with the sealer. Use even strokes and make sure the entire sign is coated. Allow the sealer to dry completely. Rinse out the cup and the brush.

2 Pour the paint into the plastic cup. With the brush, coat the sign with the paint. Use nice even strokes. Allow the paint to dry completely.

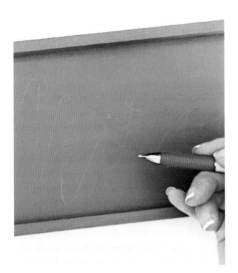

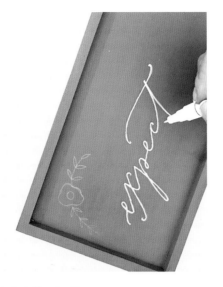

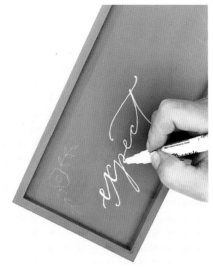

Draw Out Your Design

3 With the chalk pencil, lightly draw the design on the wooden sign. If you make a mistake, you can easily erase the chalk. When drawing out the phrase, be sure to leave plenty of room between the letters. I added a flower with stems and leaves in the top left corner.

Paint the Letters

4 See Prime the Markers, below. With the extra-fine point white marker, begin tracing the lettering. Make smooth, even strokes. The first layer of paint will look translucent. Allow the paint to dry.

5 Trace the lettering a second time to make it more opaque.

TIP ❯ **Whenever the paint flow stops, reprime the marker. Be careful not to press the tip of the marker down while painting because a blob of paint may flow out of the tip.**

PRIME THE MARKERS

Before painting with acrylic markers, you will need to prime them. First shake the marker several times. You will hear balls moving back and forth inside the marker as you shake it. Remove the cap and place the tip of the marker straight down on a piece of card stock. Push the body of the marker down and then gently release. Continue this motion until the paint begins to flow from the tip of the marker. Your marker is ready to be used. You'll need to prime each marker before using it.

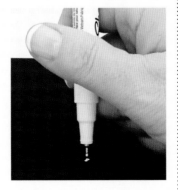

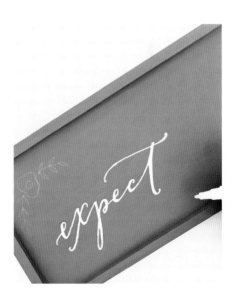

6 To create a faux calligraphy look, paint a line parallel to the downstroke of each letter. You will need to repeat this process because the first layer appears translucent.

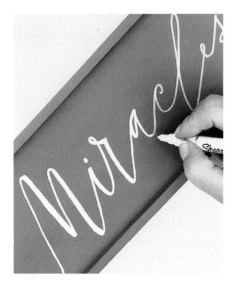
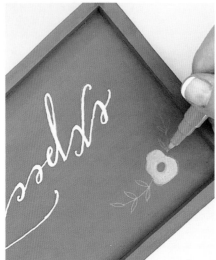
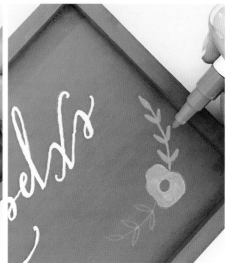

7 Using the fine-point white marker, repeat Steps 4–6 for the word *Miracle*.

Paint the Flower

8 Using the fine-point pink marker, fill in the flower drawn with the chalk pencil. Allow it to dry, then repeat. With the green maker, carefully trace the stem and fill in the leaves. Allow them to dry and then repeat. Work in sections to avoid accidentally smudging wet paint with your hand or arm. (You can even turn the sign upside down to get a better angle as you paint.)

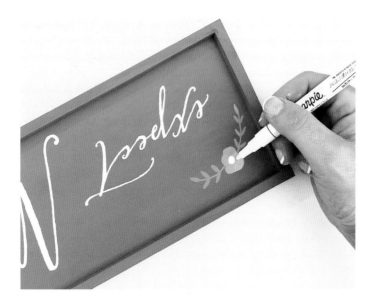

Add the Final Touches

9 Add a white outline to the flower with the fine-point marker to make it pop out from the blue background and a white heart between the words to fill in space and add a whimsical touch.

VARIATIONS

There are many blank signs, boxes, and other wooden objects you can letter on.

❦ Create a special box for keepsakes by lettering the recipient's name on it.

❦ Make feathered friends feel at home by lettering "Welcome" on a birdhouse.

❦ Letter a child's name or short quotation on a wooden letter.

❦ Frame a meaningful photo and add the subjects' names or an important date on the frame.

❦ Upcycle a piece of wooden furniture with lettering. This would work well in a child's room or vacation home.

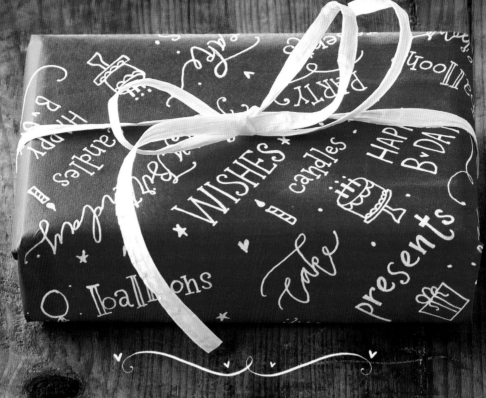

PERSONALIZED GIFT WRAP

When you wrap a gift with custom-lettered paper, the wrapping is often a bigger hit than the present! My friends and relatives often save the paper as a keepsake. For best results, I recommend a heavy, noncoated paper like the kraft paper that was used for this project. It's sturdier than typical wrapping paper, and some glossy papers may cause the ink to bubble or smear. Embellish the wrapped gift with a complementary ribbon or other decorations.

SUPPLIES

KRAFT WRAPPING PAPER

OPAQUE WHITE PEN: UNI-BALL SIGNO BROAD UM-153 GEL PEN

SCISSORS

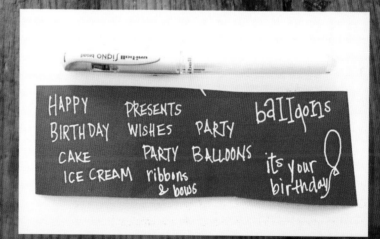

Brainstorm Ideas

1 First, make a list of words and phrases related to the theme of the gift you'll be wrapping. Here, I'm creating wrapping paper for a birthday present, so I listed words and themes related to birthdays.

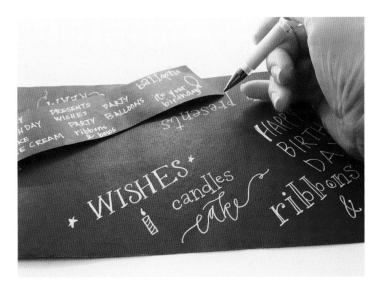

2 Next, on a scrap piece of kraft paper with the white opaque pen, begin creating various lettering designs using the words from your list. You can also draw corresponding illustrations. Evaluate which designs you like best.

Create the Paper

3 Determine the amount of paper you will need to wrap your gift. Cut the paper in the required dimensions.

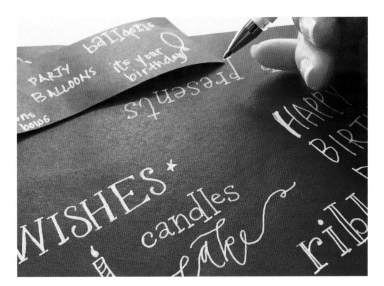

4 Now the fun part begins. Beginning In the center of the paper, letter your design. Work in a circular direction and space the designs so that a design or word is not repeated too close to one of its own kind. Keep working until the paper is filled.

VARIATIONS

♥ Create a corresponding custom gift tag.

♥ Remember those grocery-bag covers we used to put on our schoolbooks? Wrap journals or books you'd like to protect in your hand-lettered paper.

♥ If you're making wrapping paper for a birthday, include the recipient's name and yours on the paper. It will serve as a gift tag as well!

♥ Try the same hand-lettering techniques on plain gift boxes or bags.

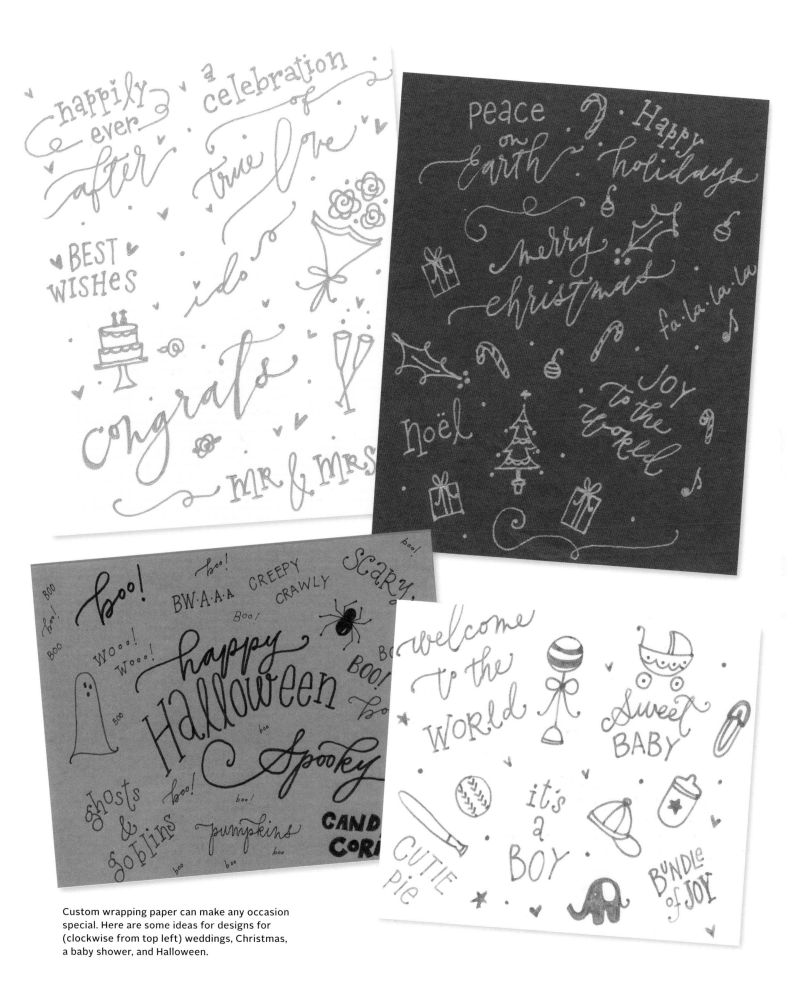

Custom wrapping paper can make any occasion special. Here are some ideas for designs for (clockwise from top left) weddings, Christmas, a baby shower, and Halloween.

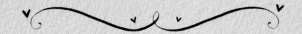

ETCHED METAL MONOGRAM
STATIONERY

Metal etching is much simpler than it looks, and there is something very cool about seeing your lettering forever etched into metal. The ferric chloride used in the technique will etch copper, brass, or nickel silver (but not sterling silver). For this project, I combined an etched-metal monogram, handmade paper, and calligraphy to give this wedding invitation Old World charm.

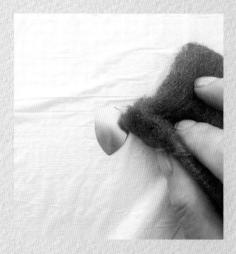

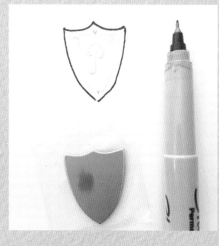

Prepare the Metal for Etching

1 Wash the metal blank with soap and warm water. Dry completely. Gently rub the metal blank with steel wool to ensure the metal is clean. Trace the blank on copy paper and sketch designs within the traced marking.

Create the Design

2 Trace around the blank with a pen or pencil on copy paper. Sketch the design for the metal blank within the tracing. Place the blank on a piece of packing tape 2–3" (5–7.5 cm) in length. The tape will protect the back of the blank from the etching solution. Fold the tape on each side to create a holder.

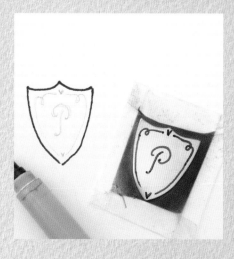

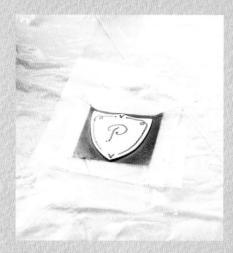

Etch the Metal

3 Draw the design on the metal blank with a black permanent marker. The marker acts as a resist to keep the etching solution from eating away the metal in those areas. Color the edges with permanent marker.

4 Cut a piece of packing tape approximately 8–10" (20.5–25 cm) long. With the design facing up, place the metal blank in the middle of the strip of tape, sticky side up.

TIP › **If you make a mistake, erase the design by rubbing it with steel wool.**

SAFETY FIRST!

Ferric chloride is an acid. When working with it, be sure to wear rubber gloves, safety glasses, and an apron. Work in a well-ventilated area away from pets and children. Ferric chloride can be used to etch several times before it stops working effectively and you will need to dispose of it. I keep the remaining solution in the plastic container with the lid sealed. Be careful when disposing of ferric chloride. Do not pour the solution down the drain. It can damage your metal sink and drains. You can neutralize the solution by adding baking soda to it and then dispose of it as sludge. Check with your local hazardous waste facility for the proper disposal of the solution.

5 Put on your safety glasses, rubber gloves, and apron. Fill one container about half full with ferric chloride. Lower the metal blank face down into the solution, but don't let it touch the bottom. Attach the tape to each side of the bowl. Let the metal sit in the solution for 20 minutes.

6 Gently lift one side of the tape to see the results of the etching. Run a toothpick across the metal. If you can feel the edges of the letter, the etching is complete. If not, place the metal blank back into the solution. Recheck in 5-minute intervals.

7 Mix 2 tablespoons (15 grams) of baking soda with 1¼ cups (300 milliliters) of water in the other plastic container. Place the metal blank into the baking soda bath, which acts as a neutralizer and halts the etching. Let the metal blank sit for about 10 minutes. Remove the tape and wash the blank with soap and water and dry thoroughly.

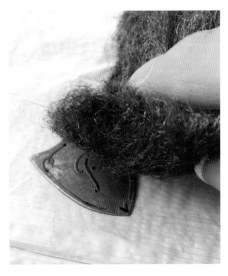

8 Use the steel wool to remove any of the remaining marker.

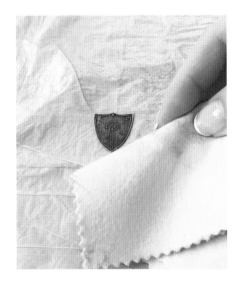

Design and Print the Stationery

9 Shine the metal blank with the polish cloth. See Safety First! on the opposite page for information on storing and disposing of the solution.

10 In a word-processing or graphic-design program, create a new file using the dimensions of the stationery paper. Type the details, leaving a space for the etched monogram.

. .

TIP ❯ **To see which side your printer prints on, mark an X on a sheet of copy paper and print a copy of the invitation.**

. .

11 Place the printed copy on top of a lightpad, then place the handmade paper on top of the printed copy. Line up the paper to the printed design and tape it into position with a low-tack masking tape. Make sure that the paper is smooth as you tape it down so it doesn't buckle while in the printer.

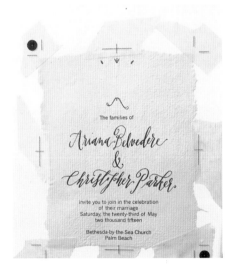

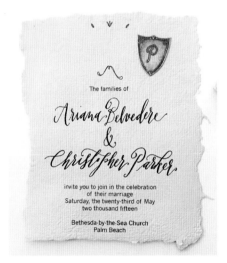

VARIATIONS

♥ **Add a patina to the etched piece to highlight the etching. There are many books and online tutorials that will show you how to use specialized products such as liver of sulfur or household materials like salt-and-vinegar potato chips!**

♥ **Use this technique to create pendants and other jewelry. Try lettering a phrase around a bangle bracelet or even a ring.**

12 Load the paper into the printer facing it in the paper tray specific to how your printer operates. Print out the design. Gently remove the tape from the handmade paper.

Assemble the Stationery

13 Adhere the etched monogram to the stationery using an adhesive runner to tack it into place. Coordinate the stationery with handmade paper envelopes and response cards.

CHALKBOARD
GIFT TAGS

Chalkboard lettering is so popular right now. You'll love making these chalkboard-style gift tags that will complement any gift. Not only are they easy to make and inexpensive, but they're also foolproof! Because you'll be drawing in white charcoal, you can simply erase any errors and begin again, but the lettering will hold up through normal handling.

SUPPLIES

BLACK CONSTRUCTION PAPER
OR CARD STOCK (OPTIONAL)

WHITE CHARCOAL PENCIL:
GENERAL'S CHARCOAL WHITE

BLACK GIFT TAGS

SCISSORS

TWINE

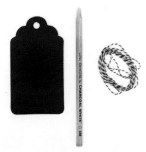

Design Your Message

1 If you like, you can design your layout using black construction paper or black card stock before you begin drawing on the gift tag.

Draw the Flower Design

2 Draw a circle with a dot in the upper left corner of the tag with a white charcoal pencil. Draw a curved line on each side of the circle for stems. On one curved line, draw three pairs of pointed ovals to represent leaves and one pointed oval on the end of the stem. Repeat on the second curved line.

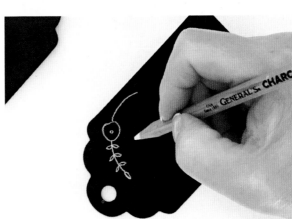

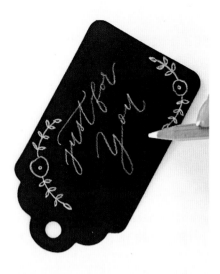
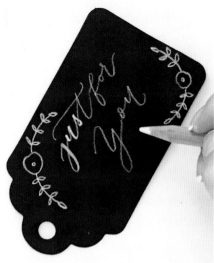
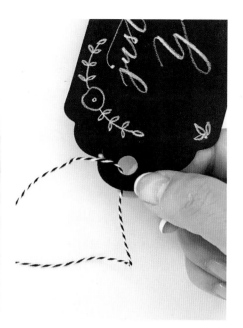

Add the Twine

3 Repeat Step 2 to create the same design in the opposite corner of the tag. Lightly sketch "just for you" or your chosen message in the center of the tag, leaving plenty of space between each letter.

4 Reinforce each downstroke by retracing and thickening it. Add dots to the end of the cross bar on the letter *t* in the word *just*.

5 Cut the twine into 5-6" (12.5–15 cm) lengths. Thread the string through the hole of the tag with the lettering facing up.

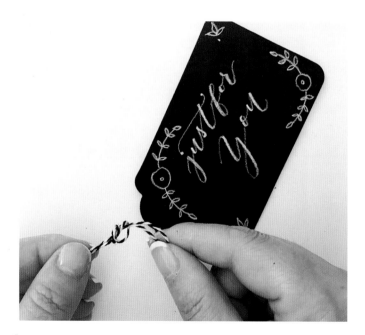

6 Take the ends of the string and bring them together. With the strings together, make a loop and slip the ends through the loop and then gently pull them to create a simple knot.

VARIATIONS

❧ **Try other colors of gift tags, but make sure they are darker shades so the white charcoal stands out.**

❧ **Create a small sign and frame it.**

❧ **Make place-setting cards and display them on small stands.**

DIGITIZING YOUR LETTERING

Part of the appeal of hand lettering is that it's a handmade art form. But there may be times that you want to digitize your lettering, such as to have your designs professionally printed or to create multiples.

You can do this in two ways depending on your needs: If you'll be using the lettering at the same scale as it's drawn, digitizing your lettering in Photoshop is fine. If you want to be able to use your lettering in a variety of different sizes, like on a business card *and* on a T-shirt, then you should use Adobe Illustrator, which allows the image to scale without losing clarity or resolution.

SCANNING YOUR IMAGE

Before you digitize your image with Photoshop or Illustrator, you have to get it into your computer. You can take a digital photo or scan it. I prefer using a scanner because it's more accurate than a camera. Unless you have very steady hands or a tripod, taking a photo can easily distort the image. I use an Epson scanner. Whatever type of scanner you have, the basic steps will be similar.

1 Open the software provided by your scanner or that is part of your computer's operating system. Place your document on the scanner. Select the Preview button to scan in the image.

2 The Preview screen will appear displaying your document on the computer screen.

3 Select the Single Marquee button located in the Marquee section at the top left portion of the window. Select the image by clicking on the screen and moving the handles of the rectangle with the cursor until the image is encapsulated within the box.

5 If everything looks fine, click the Scan button on the Epson Scan panel. This will proceed to capture the image into a digital file.

4 Click the Zoom button to see a more detailed display of your image.

6 When the scanning is complete, a dialog box will appear. Click on Save File. Your image is now available to print or edit. Unless I get a very clean scan, I usually clean it up in Photoshop.

DIGITIZING IN PHOTOSHOP

For this example, I'm using Adobe Photoshop CC. If you have an earlier version, the steps will be similar.

1 Open the file in Photoshop by selecting File from the Application Bar, then Open.

2 Navigate to the directory where your file is located. Select the file by highlighting it with the cursor and then click the Open button. Your file will be loaded into Adobe Photoshop as a locked background layer.

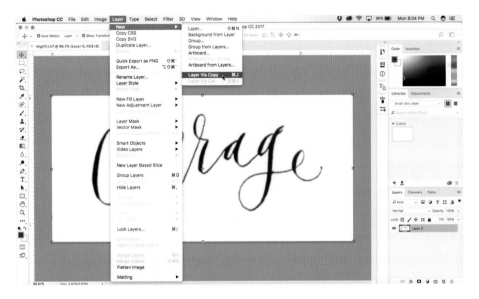

3 Create a copy of the layer by selecting Layer from the Application Bar, then New > Layer via Copy. A new layer called Layer 1 will be created.

4 Hide the original background layer by clicking the "eye" icon. This keeps the original version of the file in case you want to start over.

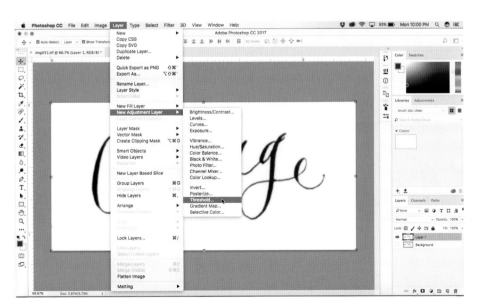

5 With Layer 1 highlighted, select Layer from the Application Bar, then New Adjustment Layer > Threshold. A new layer dialog box will appear. Click the OK button.

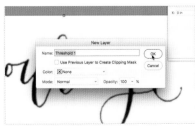

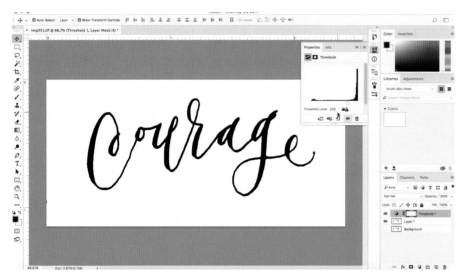

6 The Properties window will appear on your screen displaying a threshold image defaulting to a value of 128. Adjust the threshold setting (usually to the right) so that the image accurately displays your lettering. Minimize the Properties window by clicking on the double arrows in the top right corner in the Properties window.

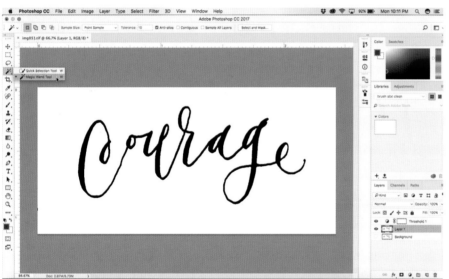

7 With the Threshold layer selected, select the Magic Wand tool from the Tool Panel. Click on the white area of the image. This will select all the white areas on the image.

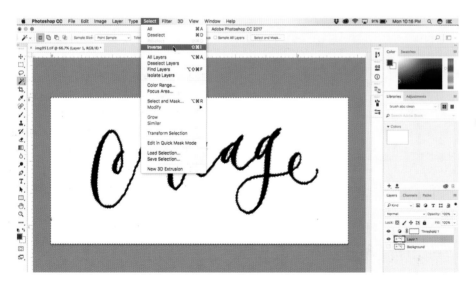

8 Click Select on the Application Bar, then Inverse. This will select the letters only.

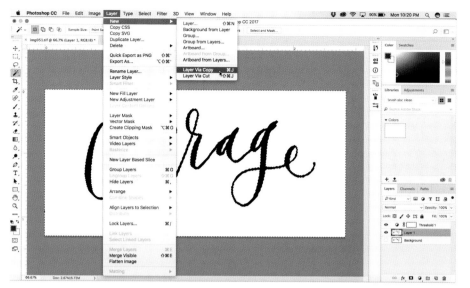

9 With Layer 1 selected, select Layer from the Application Bar, then New > Layer via Copy. This copies the letters to a new layer (Layer 2) with a transparent background. Click the "eye" next to Layer 1 to hide the layer and you will see Layer 2 has a transparent background.

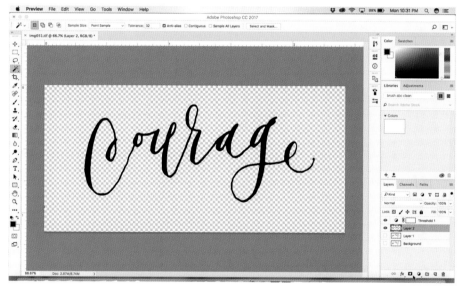

10 With Layer 2 selected, click on the Add Layer Mask at the bottom of the Layers Panel. This will add a layer mask to Layer 2. Check to ensure that the Foreground Color is set to black.

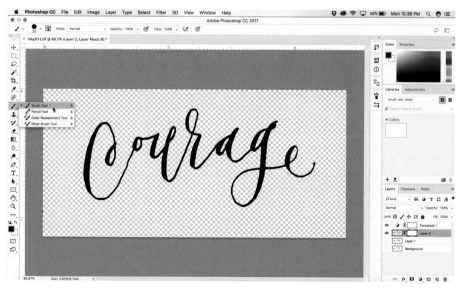

11 With the Layer Mask thumbnail highlighted, select the Brush tool on the Tool Panel. If there are any edits you would like to make to the lettering, including removing any dust specks or ink blots or slight cleanup to a particular letter, simply paint the area with the Brush tool. It's like a magic eraser, but it doesn't actually make the edits until you apply the layer mask permanently. If you change your mind about an edit you made, simply toggle the Foreground Color to white and paint over the area. What was removed will now reappear.

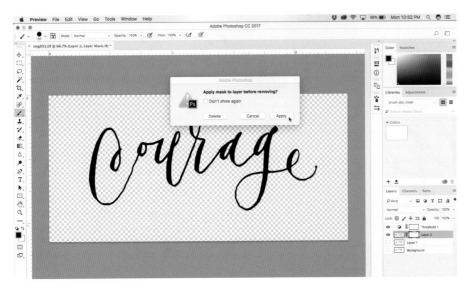

12 Once you have completed your edits, with the Layer Mask thumbnail highlighted, click on the trash can icon at the bottom of the Layers Panel. A dialog box will ask if you would like to "Apply mask to layer before removing." Click the Apply button. The edits you made are now permanent.

13 With both layers (Layer 2 and Threshold 1) selected, select Layer from the Application Bar, then Merge Visible. The two layers have now become one.

14 Select both layers (Layer 1 and Background), and click on the trash can icon at the bottom of the Layers Panel, deleting both layers.

15 Save the file under a new name (File > Save As). If you want to change the color of your lettering, double-click on the layer; the Layer Style dialog box will appear. Check the box next to Color Overlay under Styles. Click on the color box. Select the color of your choice in the Color Picker dialog box. Select OK.

VECTORIZING YOUR IMAGE IN ADOBE ILLUSTRATOR

If you're using a different version than Illustrator CC, as I'm using here, the steps may be slightly different. You can start with a Photoshop-edited image if you'd like to vectorize it.

1 Open the file you want to vectorize in Illustrator by selecting File from the Application Bar, then Open.

2 Navigate to the directory where your file is located. Select the file by highlighting it with the cursor and then click the Open button. Your file will be loaded into Adobe Illustrator as an image.

3 With the Selection tool (the black arrow icon on the Tool Panel), click on the image. You can tell if the image has been selected because a little thin box will appear around your image. With the image selected, click the down arrow button next to the Image Trace button on the Control Panel. Select Black and White Logo.

4 Select the Image Trace Panel on the Control Panel. The Image Trace Panel dialog box will display.

5 Click the arrow button next to "Advanced" on the Image Trace Panel. You have the ability to adjust the settings indicating how the letter is to be traced. Start with the Black and White Logo settings and then adjust the Path settings depending on how accurate you want the tracing to be. If you want it to be very exact, push it up to 98 percent or so. Each time you make an adjustment, Illustrator will process the change and the new tracing will display on the screen.

6 Select the Ignore White setting in the Advanced settings. This will make the background transparent and easy to use within other Adobe applications such as Photoshop and InDesign.

7 Once you have made your adjustments, select Expand and save your file under a new name by selecting File > Save As.

RESORCES

PROJECT SUPPLIES

Adobe
adobe.com

Beaducation
beaducation.com

Bee Paper
beepaper.com

Canson
en.canson.com

Daler-Rowney
daler-rowney.com

Daniel Smith
danielsmith.com

Dr. Ph. Martin's
docmartins.com

E+M Holzprodukte
em-holzprodukte.de

Ecoline
royaltalens.com

Esterbrook Pens
esterbrookpens.com

Finetec
finetec-mica.com

FolkArt
plaidonline.com

General's
generalpencil.com

Harmony
creativemark.eu

Higgins
higginsinks.com

HP
store.hp.com

Koh-I-Noor
kohinoorusa.com

Krylon
krylon.com

Kuretake
kuretakezig.us

Margo Garden Products
margogardenproducts.com

MG Chemicals
mgchemicals.com

Mod Podge
plaidonline.com

Montana
montana-cans.com

Old World Ink
oldworldink.com

Paper & Ink Arts
paperinkarts.com

Pearl Ex Pigments
jacquardproducts.com

Pébéo
en.pebeo.com

Pentel Arts
pentel.com

Prima Marketing
primamarketinginc.com

Princeton
princetonbrush.com

Prismacolor
prismacolor.com

Ranger
rangerink.com

Royal Sovereign
royalsovereign.com

Saint Signora
saintsignora.com

Sakura
sakuraofamerica.com

Sharpie
sharpie.com

Silhouette
silhouetteamerica.com

Silver Brush
silverbrush.com

Speedball
speedballart.com

Strathmore
strathmoreartist.com

Therm O Web
thermowebonline.com

Tombow
tombowusa.com

Uni-Ball
uniball-na.com

Winsor & Newton
winsornewton.com

Yasutomo
yasutomo.com

Zig
Distributed by Kuretake

TATTOO PRINTERS

MomentaryInk.com

StickerYou.com

StrayTats.com

TemporaryTattoos.com

BUSINESS CARD PRINTERS

Moo.com

TinyPrints.com

VistaPrint.com

PHOTO PRINTING

ArtsyCouture.com

Shutterfly.com

Snapfish.com

STAMP MAKERS

RubberStamps.com

RubberStamps.net

TheStampMaker.com

FABRIC PRINTERS

DesignYourFabric.com

Spoonflower.com

WovenMonkey.com

Zazzle.com

CALLIGRAPHY ORGANIZATION

IAMPETH (International Association of Master Penmen)
imapeth.com

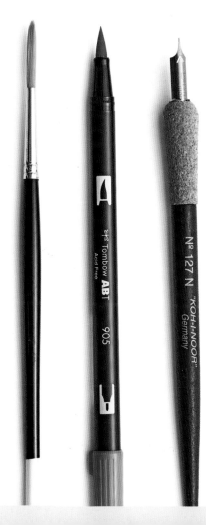

INDEX

PRACTICE PAGES

The rest of the pages in this book are designed for you to practice what you have learned. Lay translucent marker paper (such as Canson Pro Layout Marker) over them to practice the basic strokes and the letters. (You can detach them along the perforation.) The last practice sheet is blank so you can use it to work on your own lettering style or practice any other aspects of lettering you wish. Happy practicing!

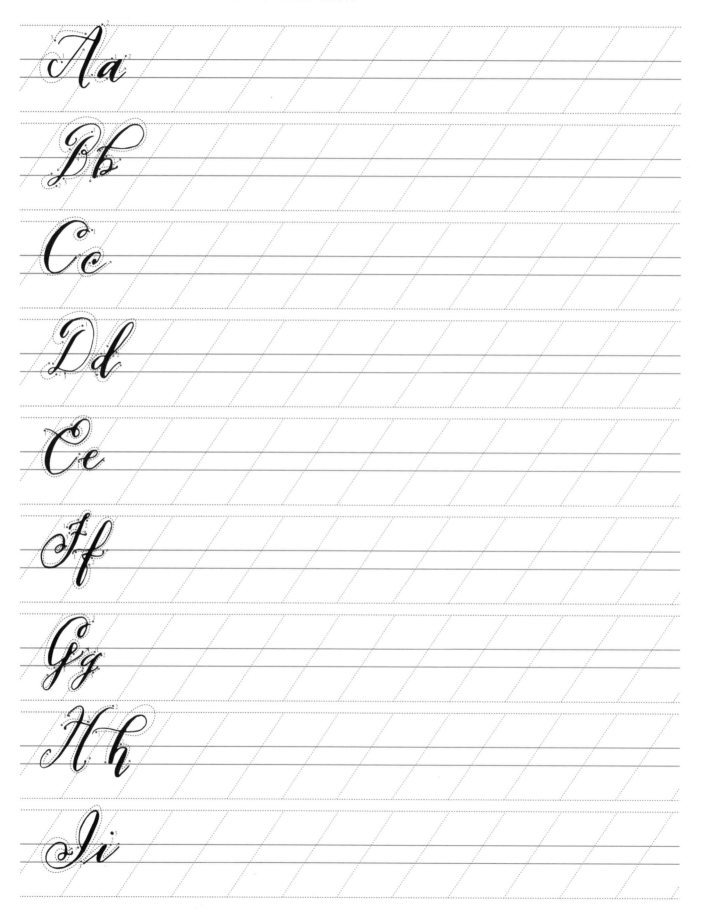

Jj

Kk

Ll

Mm

Nn

Oo

Pp

Qq

Rr

Ss

Tt

Uu

Vv

Ww

Xx

Yy

Zz

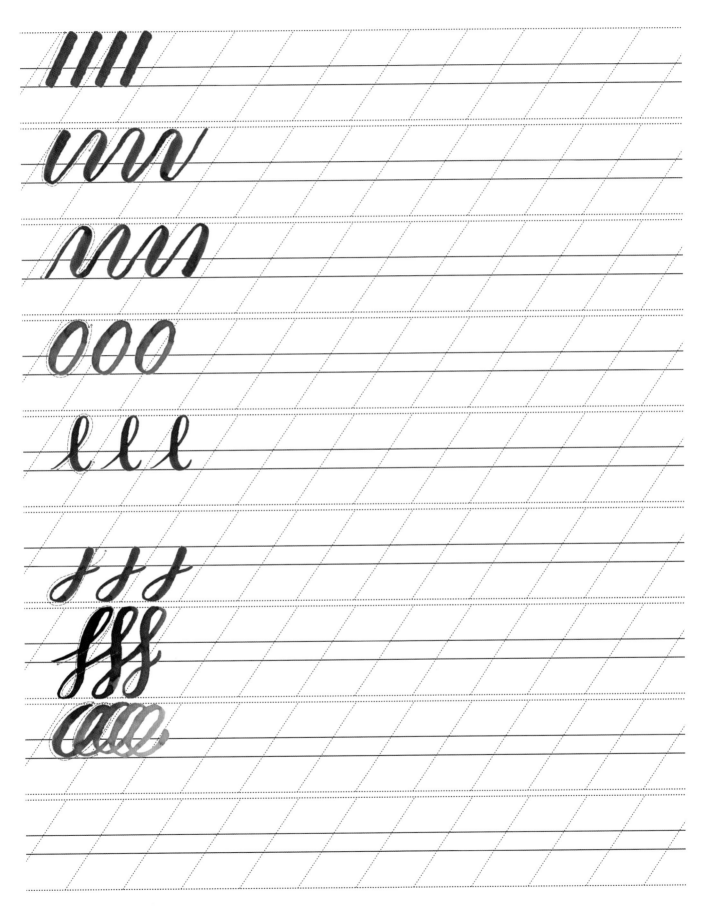

Aa

Bb

Cc

Dd

Ee

Ff

Gg

Hh

Ii

Jj

Kk

Ll

Mm

Nn

Oo

Pp

Qq

Rr

Ss

Tt

Uu

Vv

Ww

Xx

Yy

Zz